FAITH
Journaling
FOR THE INSPIRED ARTIST

· STEPHANIE ACKERMAN ·

Brimming with creative inspiration, how-to projects, and useful
information to enrich your everyday life, Quarto Knows is a favorite
destination for those pursuing their interests and passions. Visit our
site and dig deeper with our books into your area of interest:
Quarto Creates, Quarto Cooks, Quarto Homes, Quarto Lives,
Quarto Drives, Quarto Explores, Quarto Gifts, or Quarto Kids.

First Published in 2017 by Walter Foster, an imprint of The Quarto Group.
6 Orchard Road, Suite 100, Lake Forest, CA 92630, USA.
T (949) 380-7510 F (949) 380-7575 www.QuartoKnows.com

Walter Foster Publishing titles are also available at discount for retail, wholesale, promotional, and bulk purchase.
For details, contact the Special Sales Manager by email at specialsales@quarto.com or by mail at The Quarto
Group, Attn: Special Sales Manager, 401 Second Avenue North, Suite 310, Minneapolis, MN 55401 USA.

ISBN: 978-1-63322-365-3

Acquiring & Project Editor: Stephanie Carbajal
Cover design and page layout by Krista Joy Johnson
Select text by Stephanie Carbajal

Printed in China
10 9 8 7 6 5 4 3 2 1

Table of CONTENTS

Getting Started 4

Introduction to Journaling 12

Lettering Techniques 30

Flourishes & Embelishments 50

Creative Layouts & Note Taking 76

Stamp Carving 88

Mixed Media Journaling 96

Documenting Your Faith 106

Templates & Additional Materials 128

About the Author 144

Getting Started

INTRODUCTION

CREATiVELY
- WRITE
- JOURNAL
- PAINT
- DOODLE
- SKETCH

Faith Journaling for the Inspired Artist is not about religion. The purpose of this book is to share the WHAT, WHY, and HOW of creatively writing, journaling, painting, doodling, sketching, and documenting your faith in personally meaningful ways. In the pages of this book, I'll show you how I approach my own creative journey and invite you to experiment and explore so that you can discover what works best for you.

My hope is that the simple and colorful techniques I share for creating art in the margins of journaling Bibles, planners, binders, note cards, art journals, or even on little ol' sticky notes will inspire you to create something similar. When faith and creativity intersect, amazing things happen! As you work through this book, I hope you'll be inspired and encouraged to share your faith through your art.

There are no "rules," except that perfection and comparison are not allowed! I want you to give yourself permission to play, practice, try new techniques, and enjoy the process without worrying about "messing up." Have a hard time giving yourself permission? Then I will give it to you right now!

How to Use This Book

My hope is that you will refer to this book so often that it is well worn and doodled all over by the time you reach the last page. Use this book for inspiration, encouragement, and as a place to practice lettering, doodling, and coloring. Make notes in the margins and in the designated practice areas, and use a highlighter to mark the words and phrases that speak to you. Most importantly, give yourself permission to practice and play!

Let's START off BY GIVING ourselves PERMISSION to PLAY & PRACTICE

permission granted

I, _____
write your name anyway you want...

am GOING to allow MYSELF to PRACTICE and PLAY with paper, PENCILS, PENS, PAINT AS I DEVELOP MY VERY own FREE{STYLE} of LETTERING without worrying about SPACING. HEIGTH, WIDTH or REALLY anything BECAUSE I am JUST PLAYING and PRACTICING.

three cheers for PLAYTIME!

Art SUPPLIES

You might very well already have what you need to get started.

I have a ridiculous number of black pens (because you never know when the world might run out of pens); paints in 99 different, but similar, shades of color; watercolor crayons, pans, and palettes; markers (again in 99 shades of similar colors); rubber stamps; hand-carved stamps; and much more. (Don't get me started on washi tape!) Plus, I am a huge fan of blank journals. I have all of the aforementioned items piled up in my studio, just waiting for the moment that I am inspired.

But let's do ourselves a huge favor and keep it simple. Start with a few pens, a pencil, an eraser, some watercolors, a brush or two, a paper towel for blotting, and the permission to just play and practice. (If needed, go back and read your permission slip on page 7!)

Here are the basic tools I always have in front of me:
• Watercolors palettes, crayons, and pencils
• Water brush or paintbrush and paper towel
• Black Tombow® Dual Brush Pen
• Black Faber-Castell® PITT® Pen
• Black Micron® .03 liner pen
• Black Uni-Ball® Signo 207 micro pen
• Mechanical pencil
• White eraser

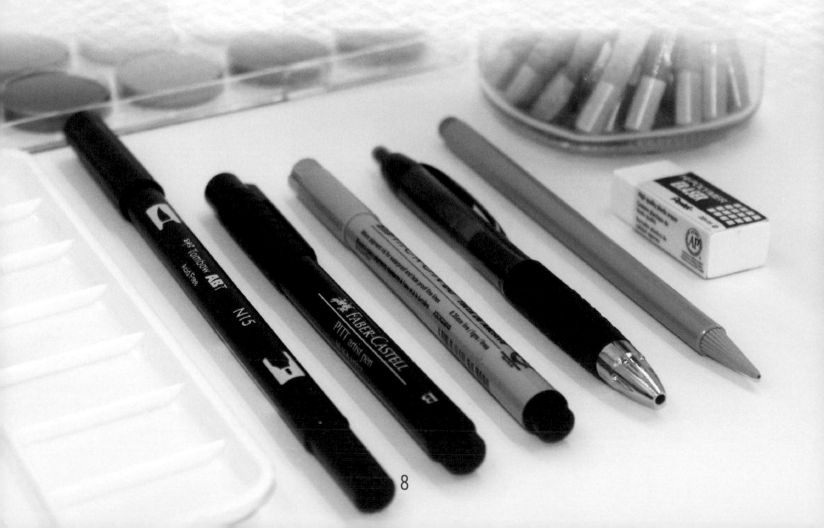

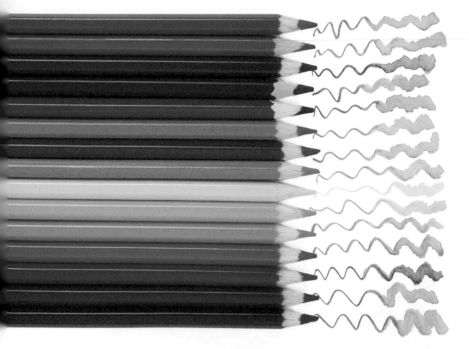

WATERCOLORS

Watercolors come in multiple forms, including tubes, pots, pans, pencils, and even crayons! A watercolor pan palette is great to have on hand for making pretty washes and backgrounds. Watercolor pencils (shown here) and crayons are also perfect tools for this kind of artwork, because they give you lots of control. You can use watercolor pencils just like regular colored pencils, or you can apply water over your strokes to create the watercolor look.

ARCHIVAL INK PENS

Archival ink pens, such as Micron and other high-quality art pens, are special, because the ink is resistant to fading or discoloration. Although more expensive than traditional pens, they are great tools to have on hand if you want to create art that will last.

BRUSH PENS

There are many types of brush pens available. Some have small nibs, and some have large nibs. The nib on a brush pen behaves like a paintbrush and produces thick strokes when you apply heavy pressure and thin strokes when you apply light pressure. I like to use Tombow® Dual Brush Pens, because they have both small and large nibs. You can use brush pens for lettering, as well as coloring.

WASHI TAPE & STICKERS

Washi tape comes in so many pretty patterns, colors, and designs. These amazing tapes use low-tack adhesive, making them easy to tear or cut. They can be written on and are removable from most surfaces, although you must be careful with the delicate, thin pages in a Bible. Washi tape, stickers, and labels are a fun way to add pops of color to your artwork.

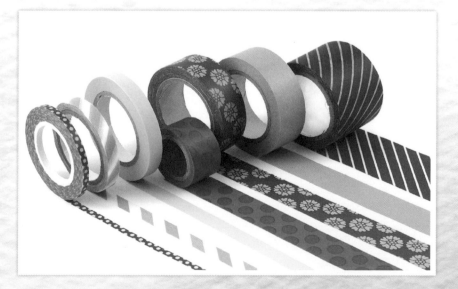

Adding COLOR

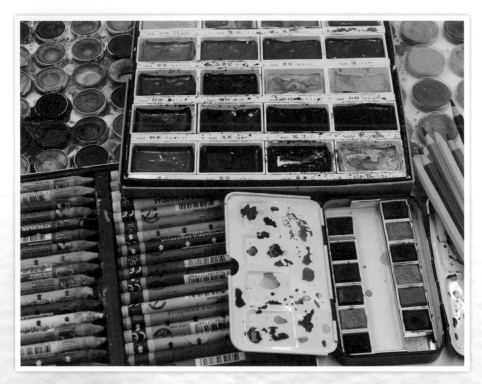

When journaling and doodling in my journaling Bible, on planner pages, or even just on a piece of plain copy paper, I almost always use watercolors and a wet brush. If you're thinking to yourself, "I don't know how to watercolor," don't panic—neither do I!

This isn't about watercolor painting. It's about using a wet brush and watercolor pencils, crayons, and palettes of color to add a little color to your journaling and art. When you take the theory part out, it simplifies a lot.

The supplies are simple:
• Water brush or water and a paintbrush
• Watercolor pencils, crayons, and/or palettes
• Paper towels
• Paper

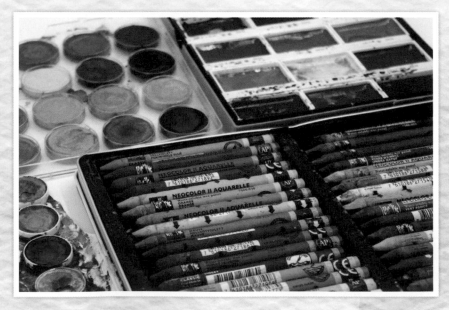

Before you start, remember to always place a sheet of paper underneath the page. This will help prevent bleeding, splats, or spills.

When adding watercolors to the pages of a Bible, journal, binder page, or anything that isn't watercolor paper, the reaction of the paper will be different. Always keep a paper towel handy when adding color to soak up some of the moisture. As the pages dry, you may see and feel a little bit of a crinkle, or what I call "curdling," but it's okay. Try to remember that it is the purpose of what you are doing—crafting faith-based art.

Take some time to play around with brushes, colors, and water. I always use water brushes, which hold water in the barrel that can be squeezed out as needed. They are great for travel and on-the-go creatives.

When I add color to my art, I don't "paint" in strokes. I simply blot the brush down and move the color around the edges, blotting as I go and using a paper towel to help with moisture as needed. Blotting the brush and color onto the page, versus using strokes, eliminates streaks and lines of color, and also makes it easy to start and stop.

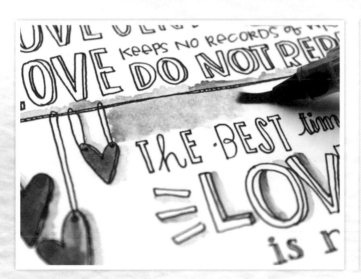

When using watercolor crayons or pencils, I always lift color from the source with my brush instead of using a crayon or pencil directly on the paper so that I don't apply too much color to the page. Taking the color from the tip of the crayon or pencil with a wet brush allows for better control on the page.

For smaller areas, the process is the same—just use less water and smaller blots of color. Keep in mind that more water on your brush equals less color and the possibility of the color bleeding through the page or out of the area in which you are working.

· · ·

If water and color make you nervous, start simple with colored pencils or crayons. Don't let the fear of messing up get in your way of creating art and journaling.

Introduction to Journaling

The Art of JOURNALING

Creating and keeping a spiritual journal can be beneficial in many ways. Let's talk about the word "journal" and what it means to be a journaler.

Oh, how we all love a new, blank journal and that crackling sound it makes when opened to the first page—fresh, clean, crisp pages just waiting to be written on!

We have the intention of journaling and may even say aloud, "I am going to start keeping a journal!" But often, after only a few pages, before even giving ourselves a chance, we rip out a page or two, remind ourselves that we don't know how to journal, and place it on the shelf with all the other unused journals.

Sound familiar?

You do *not* need to be a writer to journal. All you need is something to write with and write on. It's that simple! Learning and living by that simple thought will give you the permission and freedom to be a journaler.

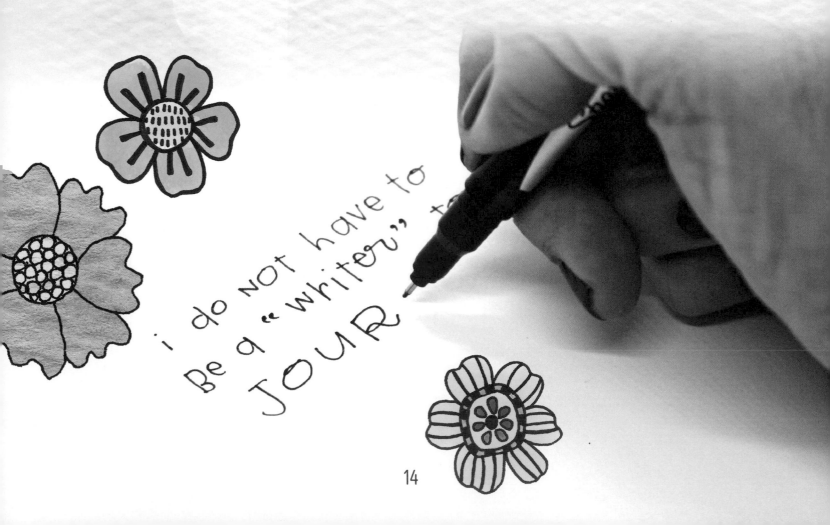

i do not have to Be a "writer" to JOUR

Just because something is simple doesn't mean it is easy. We've all seen beautiful and inspiring visuals of journals on the pages of magazines, pinned to favorite boards, and posted to social media—and along the way, we've developed the idea that our journaling should be like what we have seen. We think that if our journals aren't beautifully penned or if our thoughts don't flow off the pages like a well-written love story, we are not journalers.

Here's something you should remind yourself of often: Your faith/prayer/spiritual journal is between you and God. Style, creativity, grammar, and spelling are not important, and your journal doesn't need not be shared with the world.

Now that you've embraced your role as a journaler, let's create the place that will become our new habit!

The secret to journaling is to remember that there is no right or wrong way to do it!

The **WHY** of Journaling

If we don't remember or apply what we have learned to our daily lives, we will never grow spiritually. Recording, documenting, and illustrating our faith creates a tool and a place for us to reflect on and see what God is doing in our lives. This is a mega-benefit to creating and keeping a journal—half of the benefit is writing...and the other half is going back after some time has passed and reading!

"Each morning let me learn more about your love because I trust you. I come to you in prayer, asking for your guidance."

Psalm 143:8 (CEV)

The **HOW** of Journaling

Sometimes we want to journal, but stop ourselves before even getting started because we don't know *how* (as if there were a how-to-journal book!).

The secret to journaling is to remember that there is no right or wrong way to do it! You can journal in whatever kind of book you want, with whatever kind of writing instrument you want, whenever you want. The important thing is that you do it.

Remember: You do not need to be a writer to journal. Pick up a pen or pencil, open to a fresh page, and just start writing. It really is that simple.

The **WHAT** of Journaling

Keeping a journal not only helps us express our thoughts and feelings to God, it also provides a place for reflection, so that we can see how He has been working in and through our lives.

You might start your journal with simple words—focus, surrender, confused, grateful, blessed, overwhelmed. Starting with just one word will likely lead you into thoughts. Record those thoughts. If you find yourself overthinking the process, take a moment to put a stop to your overcritical mind.

Let's do this together! Prompts and exercises can help you overcome the challenge of knowing what to write about in your journal. If you're still stumped, try working through these exercises to get yourself in the right mindset.

EXERCISE NO. 1 — JUST WRITE

Grab a pen and paper and write these words: *I do not have to be a writer to journal.* Don't forget to record the date and time for later moments of reflection.

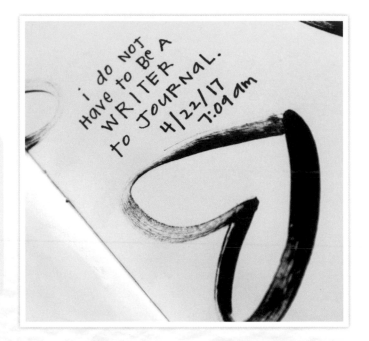

Once I wrote this phrase, something dawned on me. I always say that if something dawns on you, you might want to remember it ... so write that down too!

- I do not have to be a writer to journal.
- I do not have to be a speaker to share my story.
- I do not have to go to art school to be an artist.

These thoughts came from the simple task of telling you to write down that first statement.

Try the exercise again. Maybe this time, give yourself permission to just write words, scribble out mistakes, and write down fears and worries or successes and struggles. Use the space below.

Journal here!

EXERCISE NO. 2 — ME, MYSELF & I

For this next exercise, take a look at the questions below. Choose a few to answer, or answer them all. Use the space on this page to journal some responses. Be as messy or as neat as you like. Remember: it doesn't matter what it looks like!

- What am I most grateful for today?
- What habit do I need God's help to overcome?
- What have I avoided praying about because of fear or shame?
- What am I trusting Jesus for today?
- What is my purpose?
- Do I struggle to praise God when things are tough? Do I see those times as opportunities to grow?

Journal here!

What is Bible JOURNALING?

If you're new to the concept of Bible journaling, you may be wondering what it's all about. Even if you're not new to Bible journaling, you may be looking for fresh ways to approach this meaningful and highly personal art form. So, let's look at what Bible journaling is and how to get started.

Bible Journaling Is:

- A creative way to express and document how God is working in your life
- A unique way to use sermon notes, learn scripture by using different translations, and creatively document your spiritual journey
- An inspiring way to connect with God and study the Bible in new ways
- A unique way to express how God is revealing Himself to you
- A creative way to journal, illustrate, and document what you are learning in Bible study, at church, and straight from the pages of your Bible
- Not about religion, but your relationship with Jesus

Bible journaling can lead to a life-changing habit of illustrating, documenting, praying, and reading God's Word. Every person has their own personal way of expressing their faith and creativity.

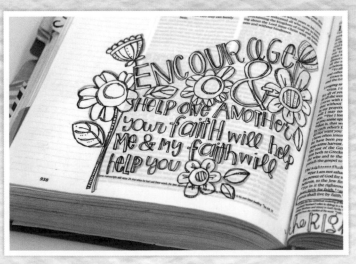

THINGS to REMEMBER

- Bible journaling is personal—just between you and God.
- It will not be and does not have to be perfect.
- It's not restricted to only the margins of a journaling Bible.
- There are no rules to what you can or cannot do.
- Likewise, there is no right or wrong way to do it.

Where to Begin

PRAY FIRST Don't try to jump in without opening your heart, mind, ears, and soul. Ask to be led, guided, and inspired to see what He wants you to see and hear what He wants you to hear. Ask for guidance, and clear your mind of distractions.

FAVORITE VERSES Begin with favorite Bible verses that speak to you.

TOPICAL VERSES Many Bibles include a topical list in either the front or back. When you need a place to start, look at those verses, and see what jumps out at you.

SERMON NOTES One of the best places to begin is with the notes that you've written down from a sermon, Bible study, or retreat.

HIGHLIGHTS Look back at other books you have read, and reread the highlighted areas. Search for Bible verses that relate to and coordinate with the quotes you have highlighted.

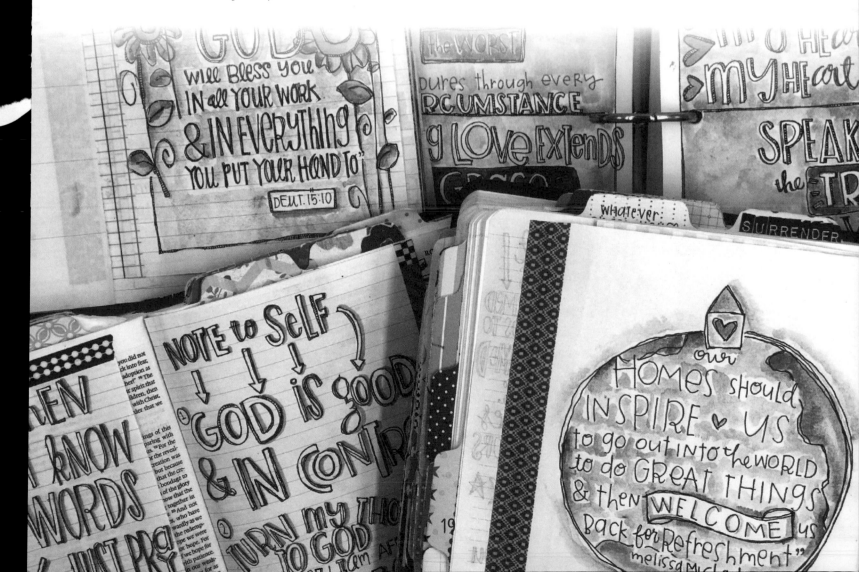

The Alternate Page

If you want to jump into Bible journaling but aren't quite ready to put paintbrush or pen to the pages of a Bible, then don't. There are many ways to document and illustrate your faith journey. I've found that creating art and journaling on an alternate page and adding it into my Bible takes away the anxiety of the question, *"What if I mess up?"* This is also a great option for those who aren't comfortable with creating in the Bible itself.

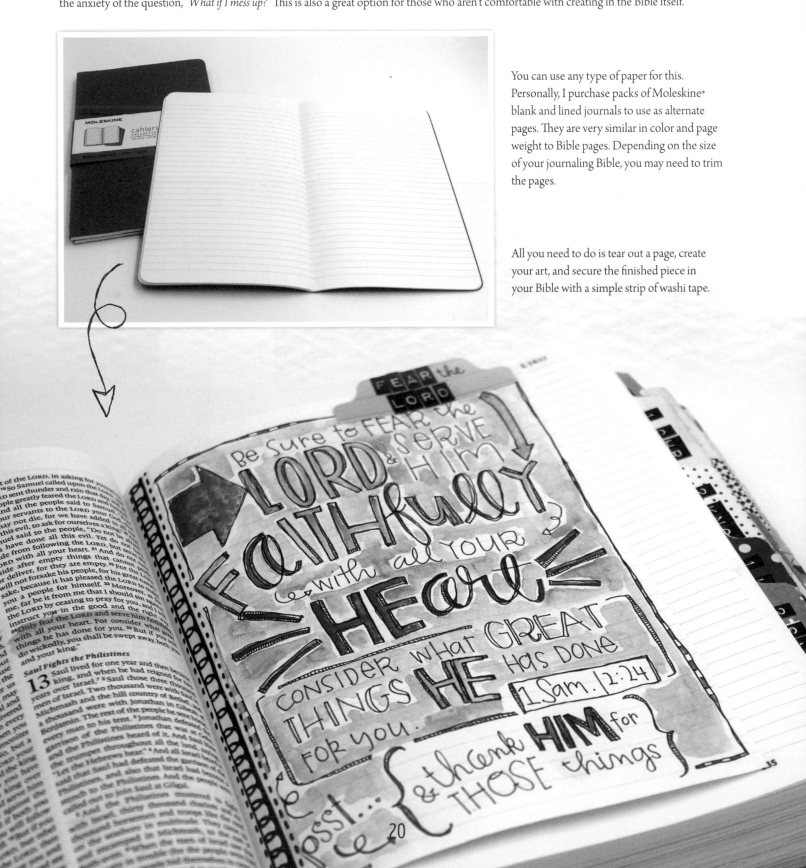

You can use any type of paper for this. Personally, I purchase packs of Moleskine® blank and lined journals to use as alternate pages. They are very similar in color and page weight to Bible pages. Depending on the size of your journaling Bible, you may need to trim the pages.

All you need to do is tear out a page, create your art, and secure the finished piece in your Bible with a simple strip of washi tape.

MY "MESS" is my Message

use my pain to HELP others...

Don't waste MY PAIN..

USE WHAT I ALREADY HAVE

> we OFTEN SUFFER but we are never CRUSHED. EVEN WHEN we DON'T KNOW WHAT TO DO, WE NEVER GIVE UP In TIMES of TROUBLE. GOD IS WITH US & WHEN we get KNOCKED DOWN, we GET UP again.
>
> ♥ 2 cor. 4:8-9 CEV

GO READ: 2 COR. 4:15 LB
2 COR 4:16-17 NLT

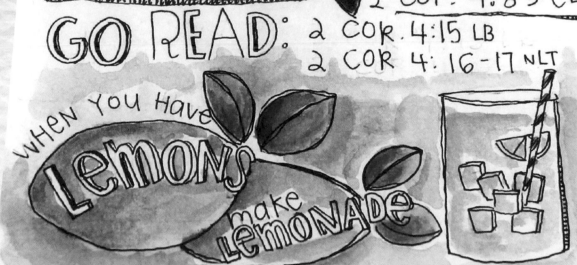

WHEN YOU HAVE Lemons make LEMONADE

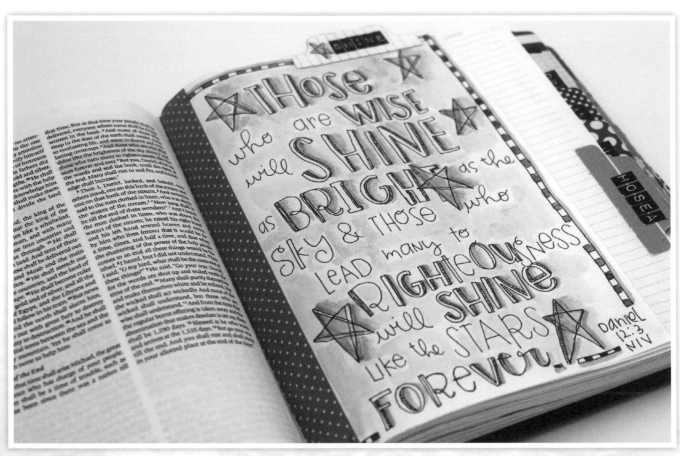

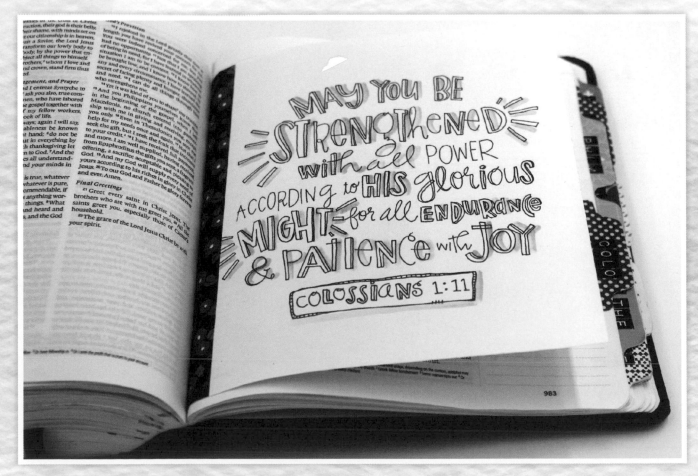

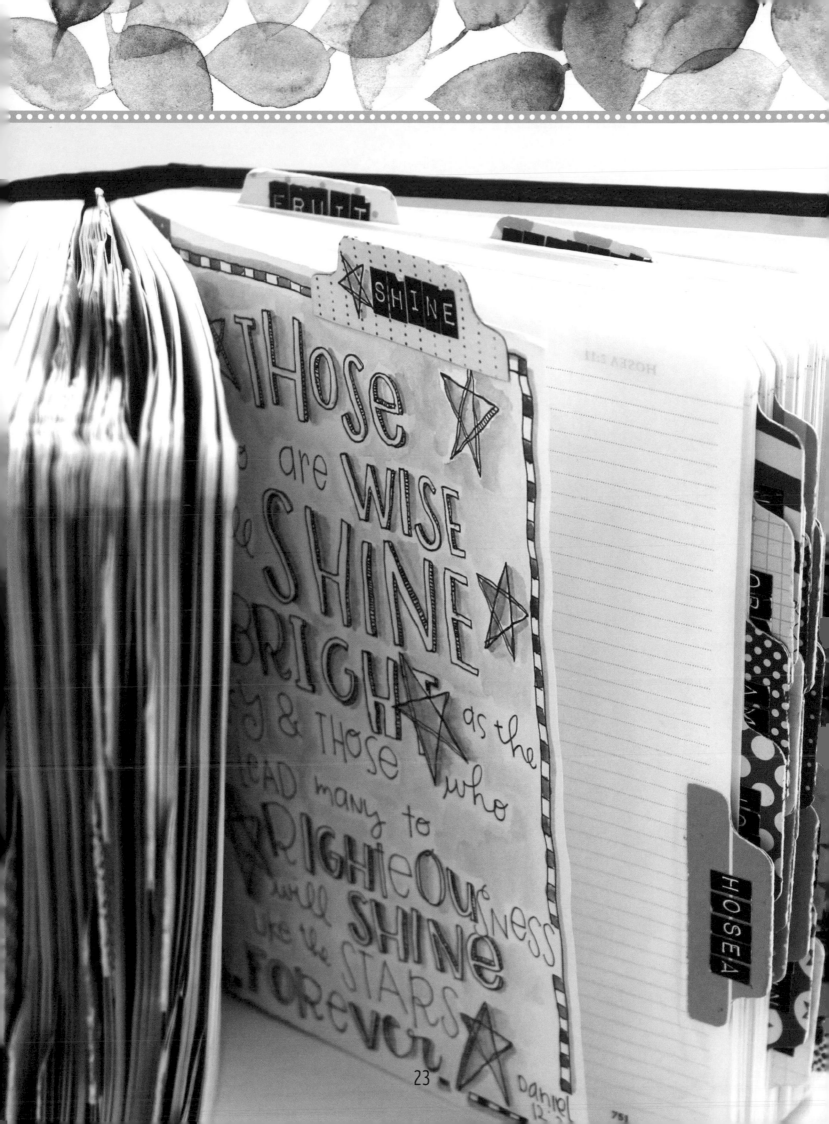

THOSE who are WISE will SHINE as BRIGHT as the sky & THOSE who LEAD many to RIGHTEOUSNESS will SHINE like the STARS forever.

SHINE

Daniel 12:3

23

Bible Journaling Basics
WHAT INSPIRES ME TO CREATE ART AROUND A VERSE IN MY JOURNALING BIBLE?

A: Before I begin my day with anything, I start with prayer. Okay, and coffee. My morning prayers lead me into my creative endeavors for the day. It's where my art and faith collide. I don't necessarily know what it will look like or what will be produced, but it is rooted in faith.

I also have two 7" x 9" binders of notes from all the sermons I have heard over the years. Something usually jumps out at me, and then I look it up in my New International Version (NIV) Study Bible. My journaling Bible is an English Standard Version (ESV). I compare the two translations, and then either create something based on the words I have read or rewrite the verse on the margin of my journaling Bible, reflecting the NIV translation.

"Highlighting" Verses

Regardless of whether I create or journal in the margin of my Bible, I always start by "highlighting" verses in light blue watercolor paint. It's a subtle color and creates flow throughout my Bible. When using watercolors, always remember to place a piece of paper UNDERNEATH the page or area you are working on. Moisten the brush, add color, and then dab/blot color over the verse. Using a dry paper towel, blot the verse. Blotting removes a little color, as well as the moisture, and helps it dry. Once the verse is highlighted, I have it to reflect on, journal about, or use as inspiration for my art when I am ready to create more.

WILL THE INKS BLEED THROUGH THE PAGES?

A: This is the most asked question in Bible journaling. I typically only use watercolors and black pen in my Bible. Previously, I used Prismacolor® markers, which contain alcohol-based ink, and they did bleed through. My suggestion is to always place a scrap of paper underneath the page you're working on so that it doesn't bleed onto other pages. Then use a black liner to outline the bleed on the reverse page to create art there as well. Look at the two images below. The bleed on the back of the page (below right) becomes its own piece of art.

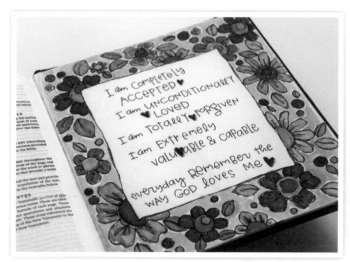
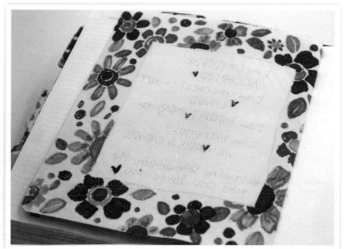

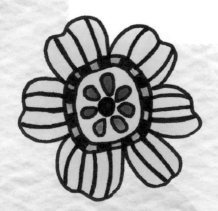

- If you find yourself consumed with how the art looks or whether it is bleeding or crinkling the page, take a break to realign your mind. Remember WHY you are doing this, and what it's all about.

- If you find that you're spending too much time critiquing your art and not focusing on what you are reading, learning, and meditating on, take a step back to refocus and adjust your thinking.

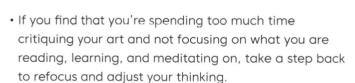

Prayer JOURNALING

Another way to express your faith is through prayer journaling. Like Bible journaling, there isn't a right or wrong approach to keeping a prayer journal. You can record your prayers in any kind of journal or notebook. You can journal them daily, weekly, or even monthly. Whatever is right for you.

> "The first thing I want you to do is pray. Pray every way you know how, for everyone you know."
>
> I Timothy 2:1 (MSG)

Why Prayer Journal?

Creating and maintaining a journal for your prayer time gives you a way to stay organized, accountable, focused, and more consistent in your prayer time—which develops a great habit!

I've discovered that the older I get, the more I find to pray for, but I am going to be super honest with you: Just moments after I quiet myself, shut my eyes, and say, "Good morning, Lord," I get distracted—I hear the dryer humming, the dog scampering in for a bone, the neighbor's car starting. I think you get the point.

If you're like me, you may commit to praying for many people, events, circumstances, and situations, but if you don't write them down, you forget! Using a prayer journal can help you follow through and stay accountable—plus it allows you to reflect and see how God works in your life through prayer.

When Should I Prayer Journal?

Personally, I like to give God the very first part of my time every day, and—without a doubt—HE provides the time I need for the rest of the day. This doesn't work for everyone, and you'll have to decide when to carve out your own time.

While I use my prayer journal in the morning, if a friend reaches out during the day requesting immediate prayer, I don't wait until the next day to write it down. I pray right then and write it down so I remember to follow up. A prayer journal is a tool to ensure that you're praying for the things that you really need to be praying for. For example, I pray for my kids and family every day, but I use my journal to truly expand my prayer time for them.

How Do I Prayer Journal?

Each of us is unique and one-of-a-kind. Your prayer journal should reflect your uniqueness. You get to decide how in-depth your entries are and what details to include or omit. The best advice I can give you is to keep it simple. Don't overwhelm yourself with another "project," because this isn't just a project—it should transform into a creative and faith-growing habit. Be inspired by what I'm sharing, as well as the beautiful examples you may find online, but stay original to you. If you find yourself starting to compare your journal to others, you may need to realign yourself with the WHY before continuing. Remember: There is no right or wrong way to do any of this.

To create a prayer journal, you can incorporate your written prayers into any sort of system you may already be using, whether it be a planner, art journal, composition book, or even a journaling Bible! Below is a list of the sections in my prayer journal, in no specific order. You might want to incorporate some or all of these sections into your own prayer journal, or you may have additional categories of prayer you'd like to include.

- **ANSWERED PRAYERS** Write down when prayers are answered and date it next to the request.

- **PRAYER-RELATED BIBLE STUDY & SERMON NOTES**

- **DAILY PRAYERS** As you're praying, write down anything you sense God is trying to tell you. This is also a place for you to journal your response to your time with God.

- **FAMILY & FRIENDS** Write short, personal prayers for family and friends concerning things happening in their lives.

- **HUSBAND & CHILDREN** In addition to a section on family, I also focus on praying for my husband and my marriage. I also have a section for each of my boys, Jack and Ben. Consider special sections for any significant relationships in your life.

- **GRATITUDE & THANKSGIVING** Consider writing a little "Thank you, Lord," for the things you are grateful for.

- **OTHERS** Pray for those who are not in your immediate family and close circle of friends.

- **QUOTES & REMINDERS ABOUT PRAYER**

- **SCRIPTURE STUDY** Write short prayers based on Scripture. When a verse catches your eye, or jumps out at you during a sermon, maybe there is something that God wants you to pay attention to. Write it down.

- **THE WORLD** Write prayers for specific issues, including government, leaders, social issues, etc.

- **SELF** Pray for the things you need to work on in your life, as well as any issues you may be facing.

Your prayer journal should
reflect your *uniqueness*.

Making a Prayer Journal

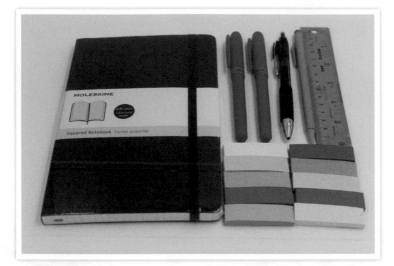

You can use any kind of notebook or journal for a prayer journal. I decided to use a softcover Moleskine notebook, sticky notes for dividers, a gel pen, highlighters, and a couple of pencils. I plan to divide my journal into 12 sections. If you are using a 3-ring binder or planner, it will be very easy to add, change, or remove sections!

The best model of how to pray is the Lord's Prayer (below).

Our Father which art in heaven,
Hallowed be thy name.

Thy kingdom come. Thy will be
done in earth, as it is in heaven.

Give us this day our daily bread.

And forgive us our debts, as
we forgive our debtors.

And lead us not into temptation,
but deliver us from evil:

For thine is the kingdom, and the
power, and the glory, for ever.

Amen.

Matthew 6:9–13 (KJV)

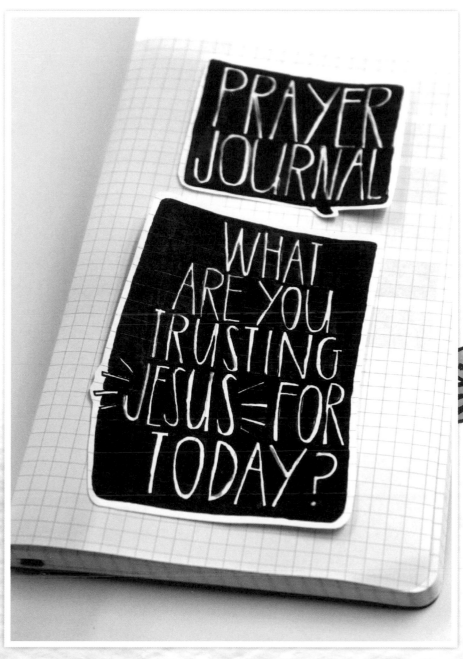

Ask yourself these questions when you don't know what or who to pray for:

- Who in your life needs prayer?
- Who needs healing?
- Who is in a spiritual, mental, physical, emotional, or relational battle?
- Who in your life deserves praise and celebration?
- Who can you pray for that does not know Jesus?

Hear my prayer, O God. Listen to the words of my mouth.

Psalm 54:2 (NLV)

Lettering Techniques

Hand
LETTERING

Remember, perfection and comparison are not allowed, so if you have already said to yourself "I hate my writing," then you need to remind yourself of a couple things:

- It's *hand*writing. When something is created by hand, It Isn't going to be perfect—and that's part of the charm!
- It's YOUR handwriting, and just like you are one of a kind, so is your writing. It is YOU.

Being inspired by what someone has created is great because it often teaches us more about what our specific styles may be—but give your own writing a chance. You are one of a kind, and no one else in the entire world can create just like you. The way you document, journal, illustrate, and create is unique to you!

Before we get into the basics of lettering, I want to share why I feel it's important to use your own writing. I have an old basket way up in my closet that contains cards from my parents, my grandma, and my Aunt Dottie. The very moment I see their handwriting, it takes me right back to them and makes my heart swell up. I wouldn't want it any other way. Handwriting is highly personal.

Right now, you are learning, practicing, and probably criticizing your own writing. But remember, it's more about the purpose than the appearance. So grab a pencil, some paper, and a pen, and let's get started.

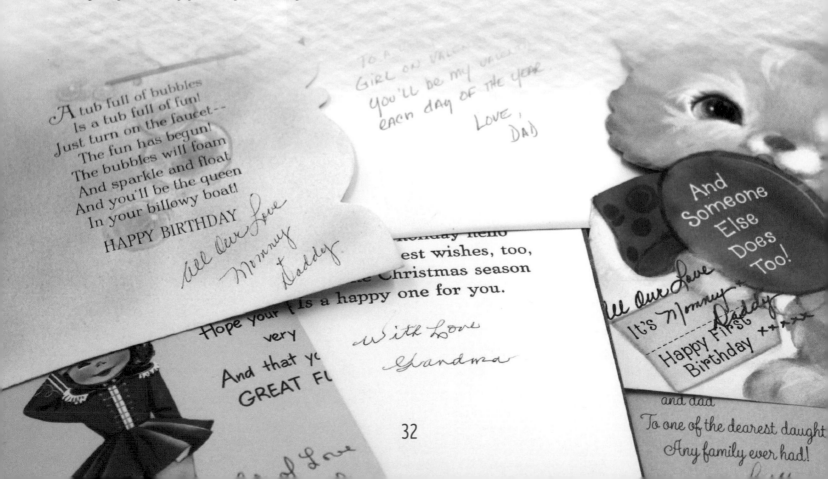

You are one of a kind, and no one else *in the entire world* can create just like you.

These exercises are very basic and elementary, but once you have them down, you're on your way to creating your very own lettering style that is unique to you. It's perfectly fine to be inspired by the lettering skills of others, but be sure to stay true to the way you create. This applies not just to lettering, but to anything you create—including your life. Use the open space on pages 34 and 35 to practice the exercises.

EXERCISE NO. 1

Using a pencil, draw a letter in both uppercase and lowercase. Start with just one letter for now, before doing an entire alphabet. Using a black pen, trace completely around the pencil line until it is completely enclosed, as shown here. Now erase the pencil, and you have drawn your first letter.

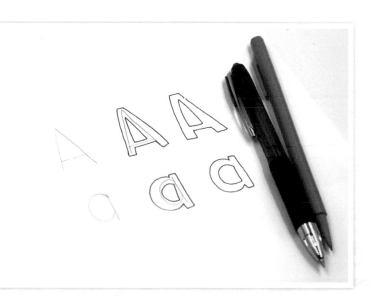

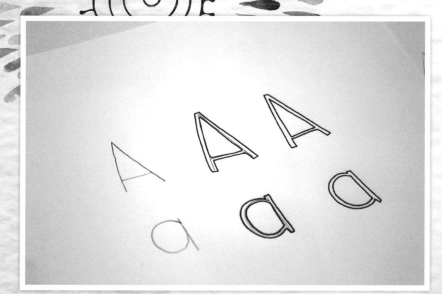

EXERCISE NO. 2

Repeat the first exercise, but when you draw lines around the pencil, stay very close to the pencil marks. This will change the entire look of your letter. NOTE: If your lines were already very close to the pencil in the first exercise, do the opposite and draw the lines further away from the pencil marks. Erase the pencil lines, and admire your letter.

EXERCISE NO. 3

Repeat the process, but this time, write an entire word. Here are a few suggestions: your name, Love, Hello. Start by drawing the letters in pencil, and then go back in with a black pen to add lines. Erase the pencil marks.

Practice Here!

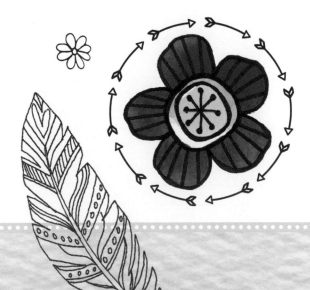

Lettering Styles &
DRAWING LETTERS

DRAW ANGLES LINES CURVES

There was a time when I was so consumed by lettering rules, spacing, placement, angles, and curves that I just quit. I found myself tearing pages out of my journals and crumpling up page after page because it wasn't perfectly aligned, slanted, or curved. I was stressing about the way it looked, rather than enjoying the process or spending time reflecting on my purpose.

We're often our own worst critic when it comes to our handwriting. We want our lettering and art to look like someone else's, but that means it wouldn't be "ours." Our creative styles, art, and lettering reflect ourselves. If this sounds familiar, you're right where you are supposed to be, and you're not alone. Get ready, because I am going to gently but persistently push you outside the bounds of your box. You're going to fuss, feel like you are struggling a little, and you're going to have to practice not being perfect, because this is HAND LETTERING, and nothing created by hand is perfect.

Nothing *made by hand* is perfect.

Let's change the term *lettering* to *drawing letters*. It takes away the "rules," and you may be surprised that it allows you to go a little more with the flow. There are thousands of lettering styles. Pop onto any social media platform, type in "hand lettering," and the possibilities are endless. Personally, I am quickly overstimulated and overwhelmed by all the styles. You have the rest of your life to work on different styles, and they will come as you practice. So for now, just like with supplies, let's keep it simple.

Together we'll learn and practice what I call "freestyle lettering."

FREESTYLE Lettering

36

Freestyle lettering is my way of teaching and giving you permission to mix and match uppercase letters with lowercase letters—and occasionally toss in a cursive letter or two. The process is the same as the exercises on page 33, but now pencil a combination of uppers, lowers, and cursives to spell out whatever you like. Don't worry about spacing or placement right now—just practice drawing the letters. Refer to the mixed-up alphabets on pages 38–44 to get your mind going in the right direction.

MIXEd UP

Choose a word to draw, and mix and match letters from my examples to make your word. Place a long and narrow letter next to a short and squat letter, and then just keep going. There is no wrong way to do this.

BIBLE JOURNaLing and LettERIng

Practice mixing and matching letters to spell out words on the following pages. Allow yourself to mess up and begin again. Over time, you'll discover and develop your own style, but you must keep practicing to be able to identify what you do and don't like. Use pages 34 and 35 to practice freestyle lettering.

A A a a a a a a a A

B B B B B B B b b B b b

C C C C C C C C C C C C

D d D D d d d d d d

e e e E E e e e E E

F f f F F f f f f F F

G g g g g g g G G

H H H h H h h H

I I i l i I I

T J J j j J J

K K k k K K k k

L L L L L L L 1

M M M M M m M M

N N n N n N N n

O O o O O o O oh

P P P P P P P P

Q Q Q q q CUE

R R R r r R R

S S S S S S S S

T t T t T T T T J t

U U U u U U U u

V V V v V v V V

W W W w W w

X X X X x X

Y Y Y y Y Y why

Z Z Z z Z Z

A B C D E F G H I J K L M N O P Q R S T U V W X Y Z

FRENCH FRYS

abcdefghijklmnopq
rstuvwxyz

Aa Bb Cc Dd Ee Ff
Gg Hh Ii Jj Kk Ll
Mm Nn Oo Pp Qq Rr
Ss Tt Uu Vv Ww Xx
Yy Zz 0123456789

FREEStyle: Thin BOXED In

Aa Bb Cc Dd Ee Ff
Gg Hh I i Jj Kk Ll
Mm Nn Oo Pp Qq Rr
Ss Tt Uu Vv Ww Xx
Yy Zz 0123456789

Freestyle WIDE BOXED IN LINES

Creative Exercise

Use the lettering examples on pages 38–44 to draw the word "Amen." All you need is a pencil, eraser, pen, and a piece of scratch paper. Choose different letter styles or follow along with my example.

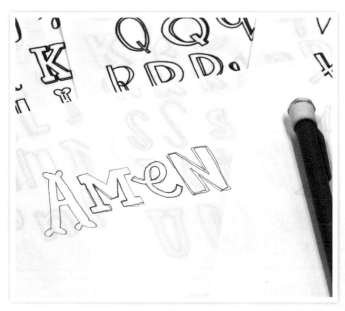

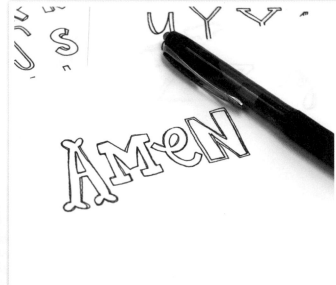

Start by drawing the word "Amen" in pencil.

Use a pen to trace over the pencil lines, and then loosely go over the pens lines again. I call this "doubling up" my lines. Allow the lines to be loose and slightly divided to create white space between. That space is the perfect place to add details like little lines, dots, solid colors, or checkerboard patterns.

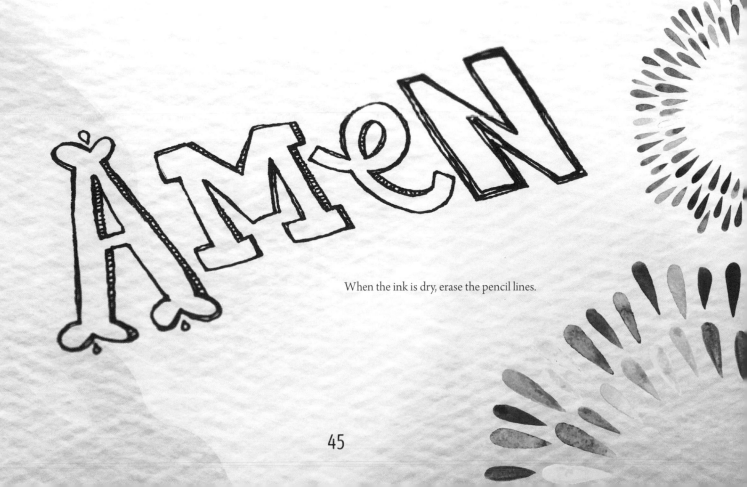

When the ink is dry, erase the pencil lines.

Drawing Letters Inside & Outside THE MARGINS

It doesn't matter if you're drawing letters on a piece of scrap paper, in the 2-inch margin of a journaling Bible, on a sticky note, or in a planner—the steps are the same. Pencil, pen, and erase!

• • •

You don't always have to double up the lines. You can add several different design elements when you draw letters. Try not to complicate it, and don't feel you must make the decision right on the spot. You can always go back and add designs as you go.

• • •

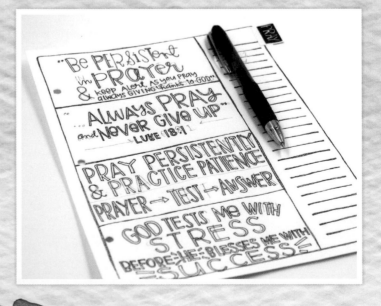

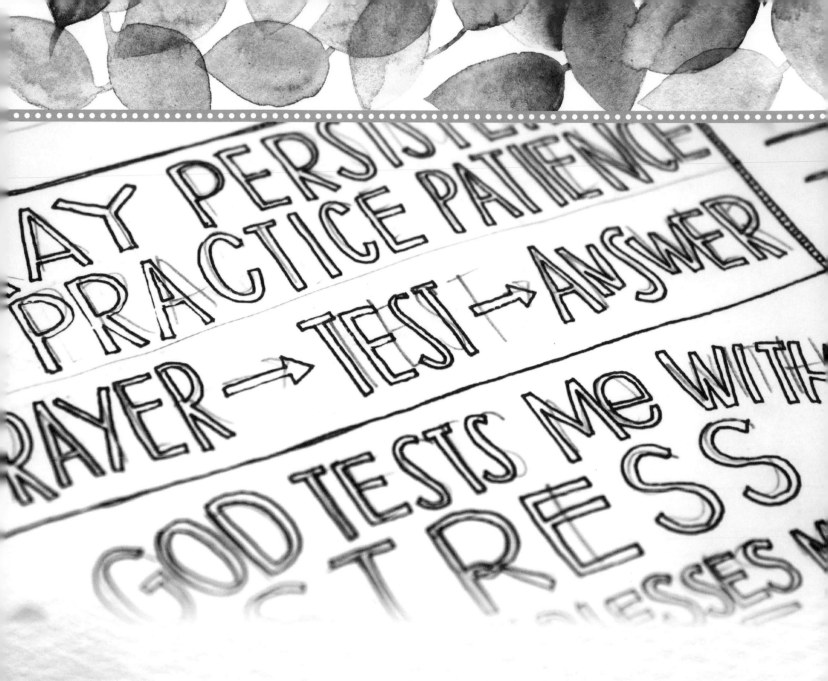

PRAY PERSISTENTLY
PRACTICE PATIENCE
PRAYER → TEST → ANSWER
GOD TESTS ME WITH
STRESS

Love listens
{two EARS...
one MOUTH}
LISTEN TWICE
as much as you speak
-IT ALWAYS

Love is patient, love is kind. It does not envy, it does not boast, it is not proud. It is not rude, it is not self-seeking, it is not easily angered, it keeps no records of wrongs. Love does not delight in evil but rejoices with the truth...

Look closely at my lines. They are wobbly and crooked, and guess what? It's OKAY! When you use your hands to create this type of art, it won't be perfect.

Once you erase the pencil lines, it's time to add some detail to either the inside of the individual letters or to the doubled-up lines around your letters.

love

Letter by Letter: A Closer Look

Look at the "Be Persistent in Prayer" before and after the lines are erased and notice how subtle marks can be made to each letter to add depth and definition.

B Added a few vertical lines in the white space

E No change

P Added a narrow line to the inside left and little lines in the white space

E No change

R Added a thin box to the outer left and a slight curved area to the inside top of the curve

S No change

I No change

S Added slight lines to the inner left and outer right curve

T No change

E Added a slight line to the inside left and filled with small lines

N Filled in the white space with a few vertical lines

T Doubled up the line on the left part of the curve

IN No change

P Added a checkerboard pattern and inked in every other box

R Doubled up lines on the inside left and outside right and filled with little lines

A Added "scribbly" lines to fill in the white space

Y Doubled up lines on the inner left and outer right and filled with little lines

E Filled in white space with vertical "scribbly" lines

R Filled in white space with vertical lines

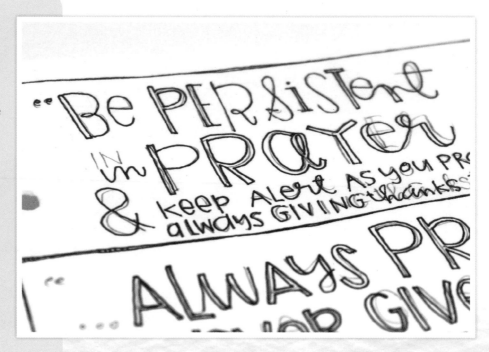

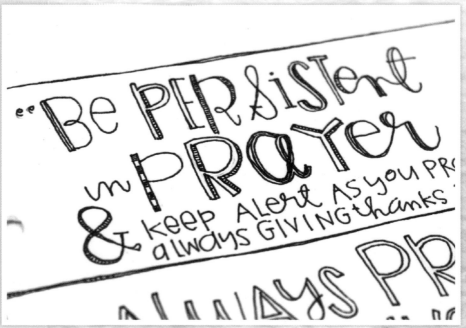

48

Now let's take a closer look at the steps for drawing the word "courage."

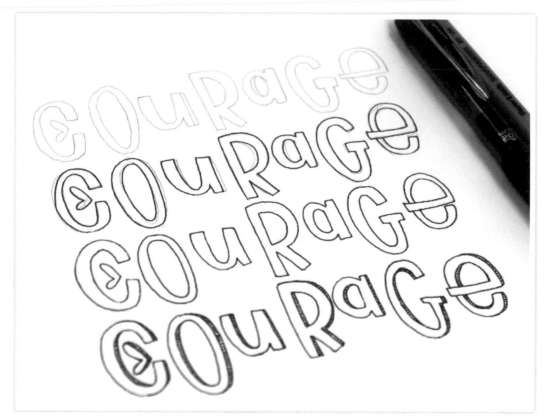

Pencil in the letters.

Trace over the letters with a pen.

Erase the lines. Instead of doubling up all the lines, I added loose lines to the inside left and outside right of each letter.

Add details, such as tiny lines, in the white space between the doubled-up lines.

Now it's time for you to take some time to practice drawing letters and words. Mix up the upper- and lowercase letters with different styles, and practice, practice, practice!

Practice here!

Flourishes & Embellishments

Speech BUBBLES

Speech bubbles are a fun and creative way to express your thoughts and are perfect for adding to your Bible journaling margins, planners, and binder pages. You can create them right on the page, or you can draw them on card stock and color them in before cutting them out.

Write the thought or verse you want to express in pencil before drawing the speech bubble. Then use a black pen to closely trace over all the pencil lines.

Next draw a speech bubble around the words in pencil, and then trace over the lines with a black pen.

Erase all the pencil lines. Then begin to fill in the white space around the words with a black marker.

Once filled in, you have a nice contrast between the words and the dark background. You can also use this technique with color for a more vibrant look!

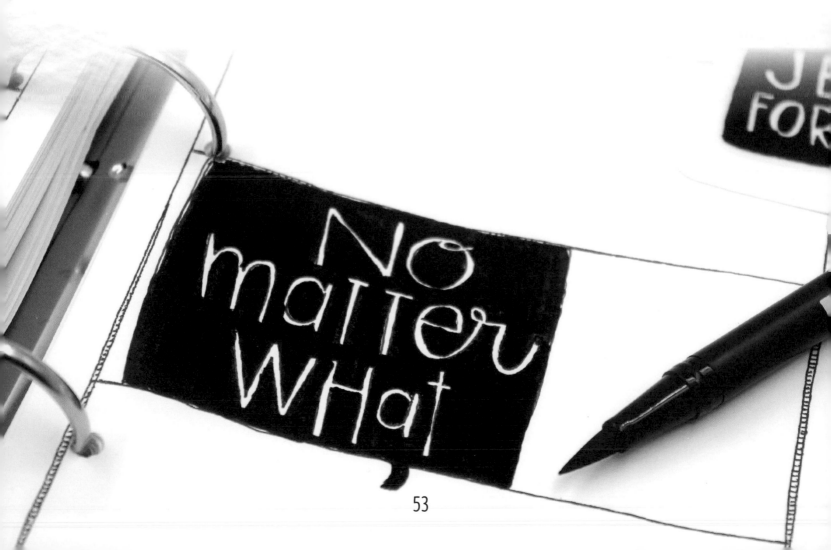

Hearts & FLOWERS

When you are journaling, illustrating, and documenting your faith, a large-scale flower explosion isn't necessary. A little doodled flower and vine, a heart, or icon here and there may be just enough. I always include a heart somewhere in my art. It stands for HE (God) and ART, the gift he entrusted me with. Little icons are perfect when you need to add just a little more to your artwork or fill some empty space.

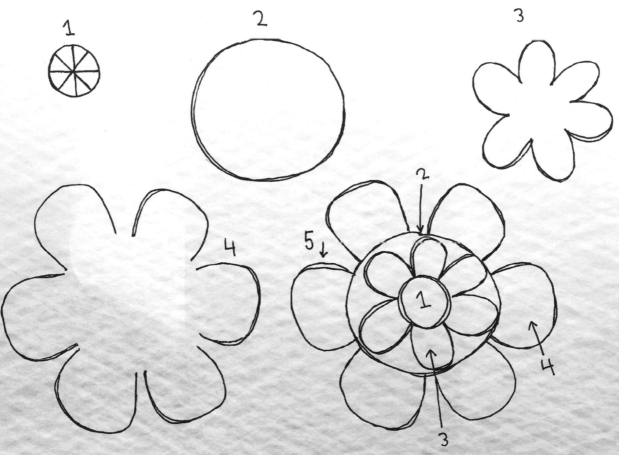

There are many different styles of flowers and hearts you can add to your journaling. No two will be exactly the same. My suggestion is to stay loose with your pen. Hearts and flowers are curvy; keeping your pen loose allows your lines to flow and not be jagged. Above is just one example you can follow to draw flowers.

Simply changing the sizes of the flower centers and petals will change the entire look of the flower. You can customize these steps to draw any number of flowers.

Everyone knows how to draw a heart, but there are lots of ways to tweak and embellish a traditional heart shape. Check out the examples on page 56 for inspiration.

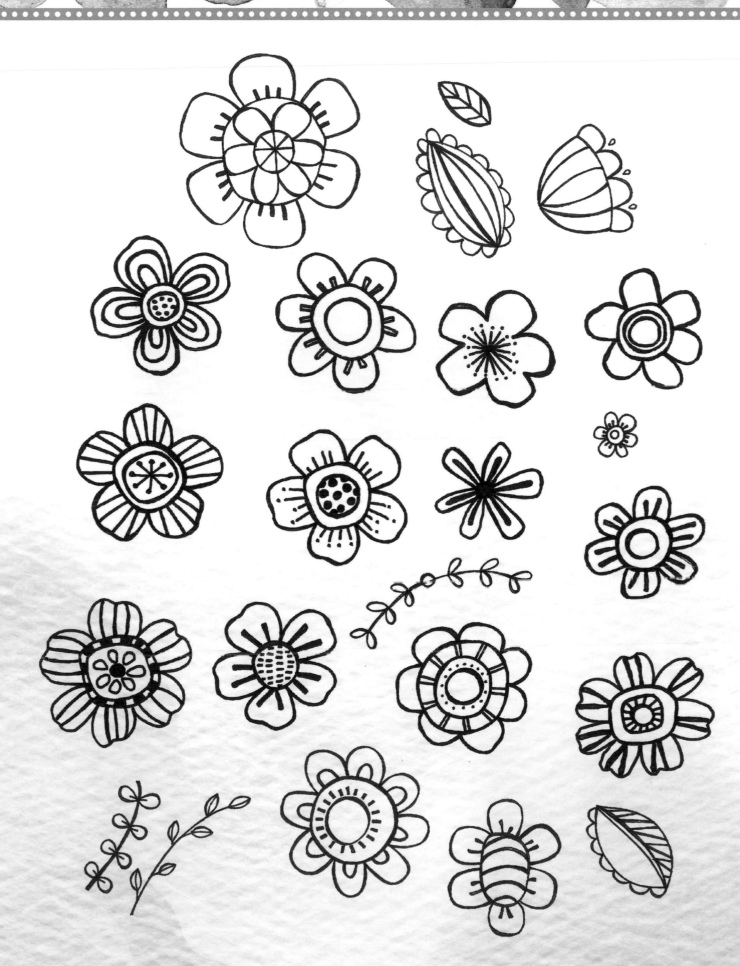

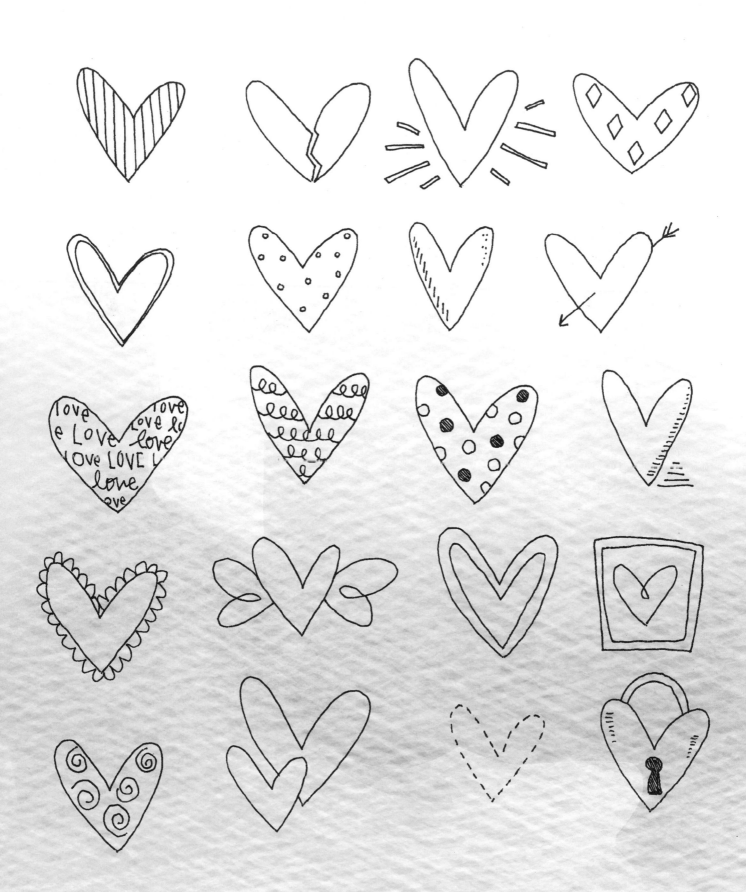

Mini ICONS

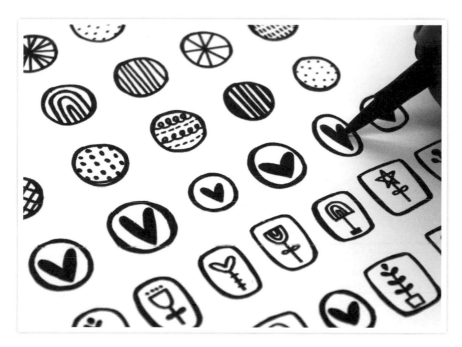

Practice doodling little icons by drawing quarter- and nickel-sized circles on a piece of paper. Add little marks, hearts, flowers, stars, dots, leaves, houses, or patterns. This is a great warm-up exercise, and along the way, you'll discover your favorite shapes and designs that will be perfect for filling a little space.

The word "key" jumped out at me in this verse, and I knew that doodling a little key would be just right. I simply took a key off my key ring, traced it with a pencil, and then went over the lines with a pen. To finish, I erased the pencil marks and doubled up the lines.

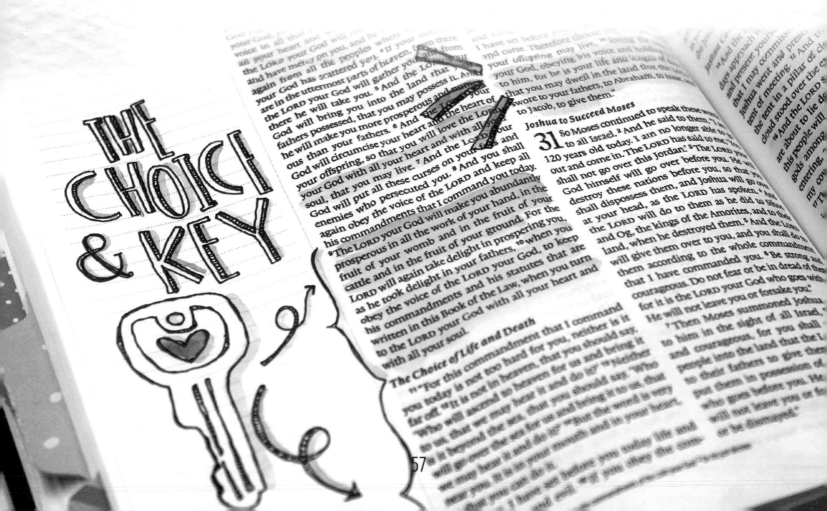

Banners, Borders
& FRAMES

Create simple borders or banners around verses that you want to highlight and remember. Keeping it simple allows you to focus more on the words than the art. Follow these simple steps to draw a basic banner in your Bible.

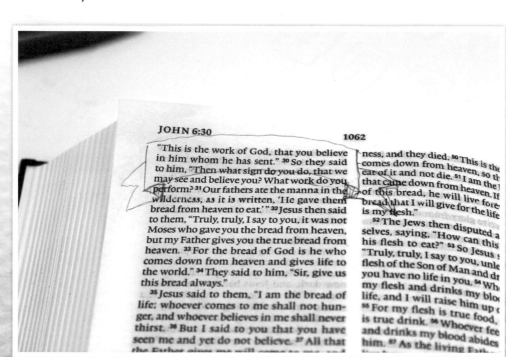

Draw a slightly curved line above the verse or quote that you want to highlight in pencil. Then draw a matching line below the verse or quote, and connect the two lines with vertical lines. Create a "tail" by drawing a line halfway up each side of the banner. Make a "V," and then connect back to the bottom of the banner.

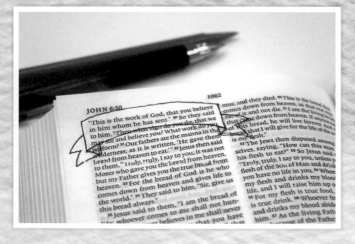

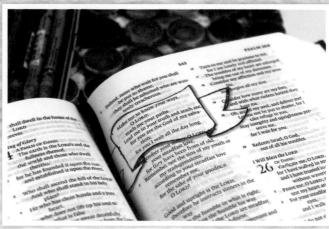

Go over all the lines with a pen, and erase the pencil lines.

Adding Details

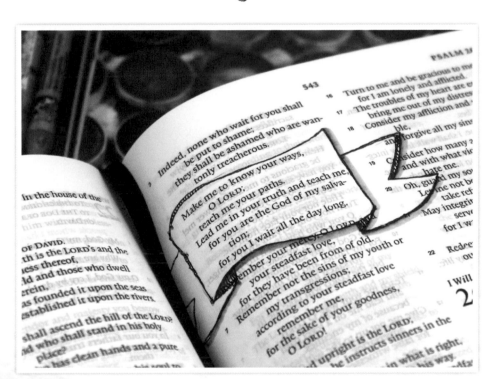

There are a few ways to add detail and dimension to your banners. Use simple lines to suggest shading and shadow.

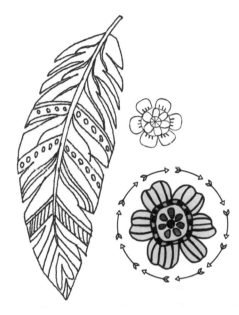

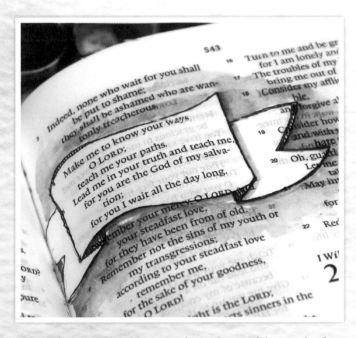

To keep the art simple, add a watercolor wash around the outside of banners and borders.

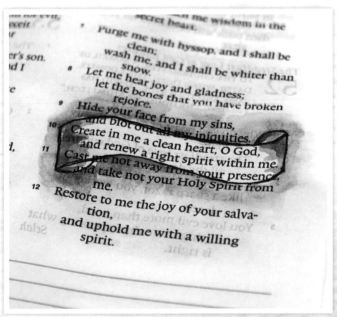

Use shades of gray to add depth and shadows.

Here are several other examples to practice drawing. Try placing some tracing paper over this page to practice drawing the banners. The more you practice, the easier it will be to draw them naturally.

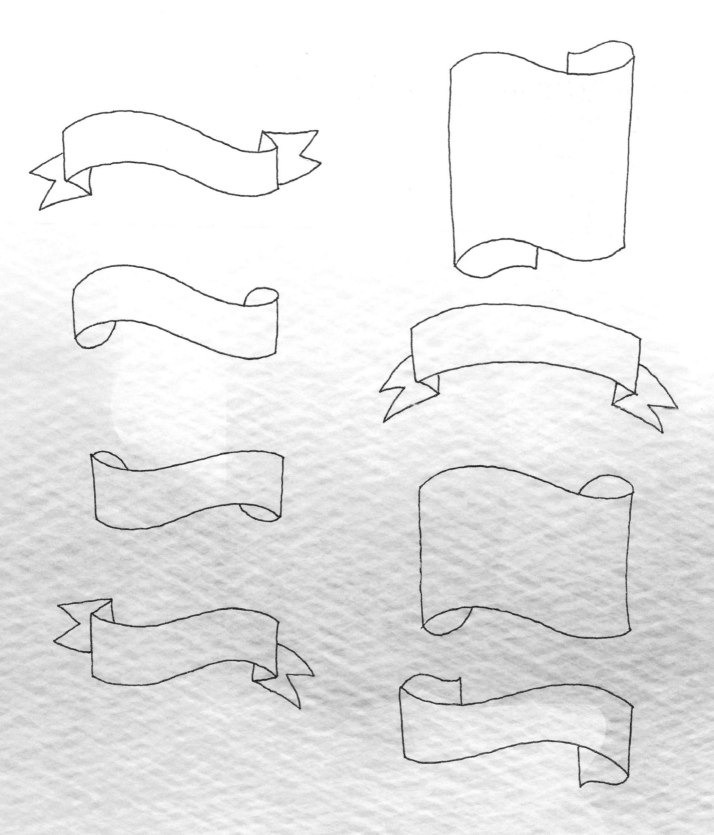

For quotes and verses enclosed in a large banner or border, consider adding flowers and leaves to cap the top.

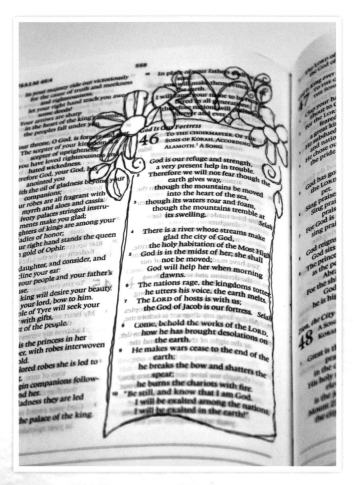

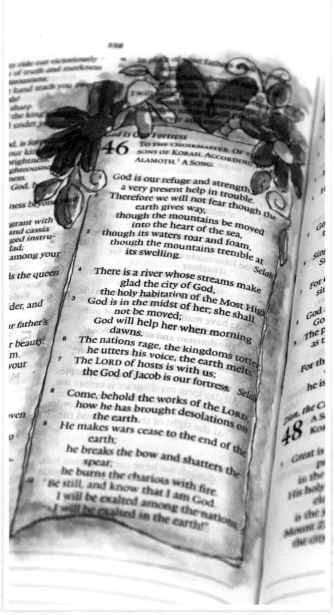

Using pencil, lightly draw lines around the left, right, and bottom sides of the verse. Add flowers, vines, and leaves to the top. Then trace over the lines with a pen. Erase the pencil marks. Double up the lines, if desired.

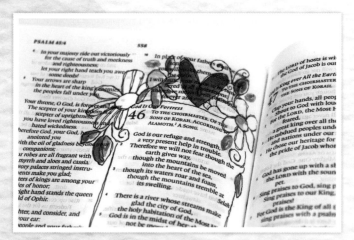

Add color with watercolor paints. If needed, you can go back with a pen and add more lines.

Add color to the inside edges of the banner and a shade of gray around the outside edges to create depth. If desired, add details to any small bits of white space created by doubling up the lines.

Feathers
& ARROWS

Feathers and arrows both make great embellishments for Bible journaling, planners, and other kinds of journals. Arrows are a little easier to draw. Before adding feathers to the pages of your journal or Bible, practice! I've found that each time I draw a feather, it comes out a little different. Once you find a style you like, go for it.

Feathers

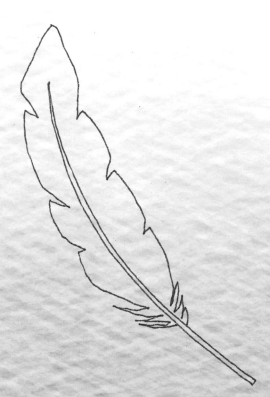

When it comes to drawing feathers, start very simple. As you get more comfortable, you can add details and color. Draw a long, diagonal line for the middle of the feather with a "V" toward the bottom. Then begin to add feathery strokes for the outer edges of the feather, with some that cut toward the center to create separation.

When you're happy with all the pencil lines, finish tracing the feather in pen, and erase any visible pencil marks. This is a very simple, basic feather shape that can be kept as is or embellished with color, designs, or patterns.

Here are some ways you can embellish a simple feather design, but the options are endless. Practice will help you get more comfortable drawing feathers and help you learn what style you like best.

WATERCOLOR FEATHERS

I love to create pretty watercolor feathers in my journaling artwork. All you need is watercolor paints and a wet brush to simply blot color inside the feather. Keep a paper towel handy to blot away excess moisture or color.

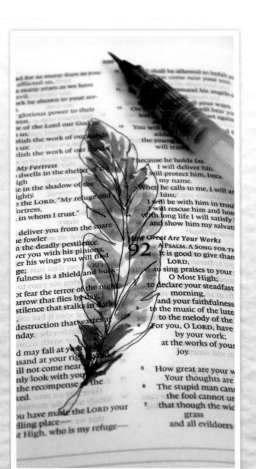

Creative Challenge

Before drawing the feather, challenge yourself to blot watercolors onto paper in the shape of a feather, and then add lines and details after the paint is dry. Cut the feather out, and use it as an embellishment or a bookmark!

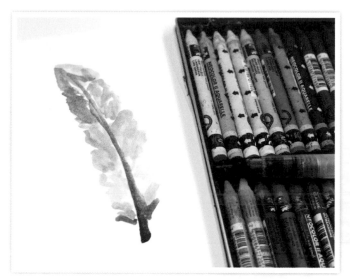

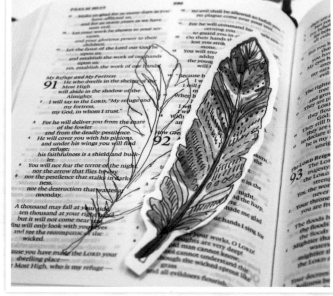

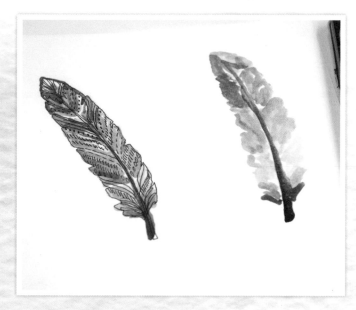

FEATHER & WING BIBLE VERSES

He will cover you with his feathers. He will shelter you with his wings. His faithful promises are your armor and protection.

Psalm 91:4 (NLT)

But for you who fear My name, the sun of what is right and good will rise with healing in its wings.

Malachi 4:2 (NLV)

Arrows

Arrows are a little easier to draw than feathers, and there are lots of ways to make them—cute, quirky, whimsical, or simple!

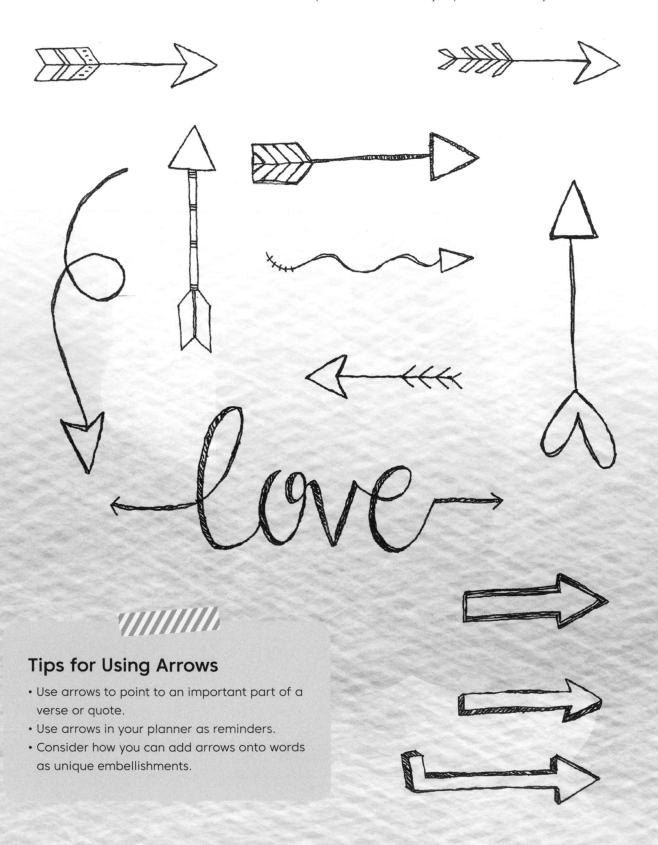

Tips for Using Arrows

- Use arrows to point to an important part of a verse or quote.
- Use arrows in your planner as reminders.
- Consider how you can add arrows onto words as unique embellishments.

Here are a few examples of arrows at work in my own journaling Bible. Arrows are a great way to fill empty space or guide the eye within a more complicated design so that the viewer knows where to look next.

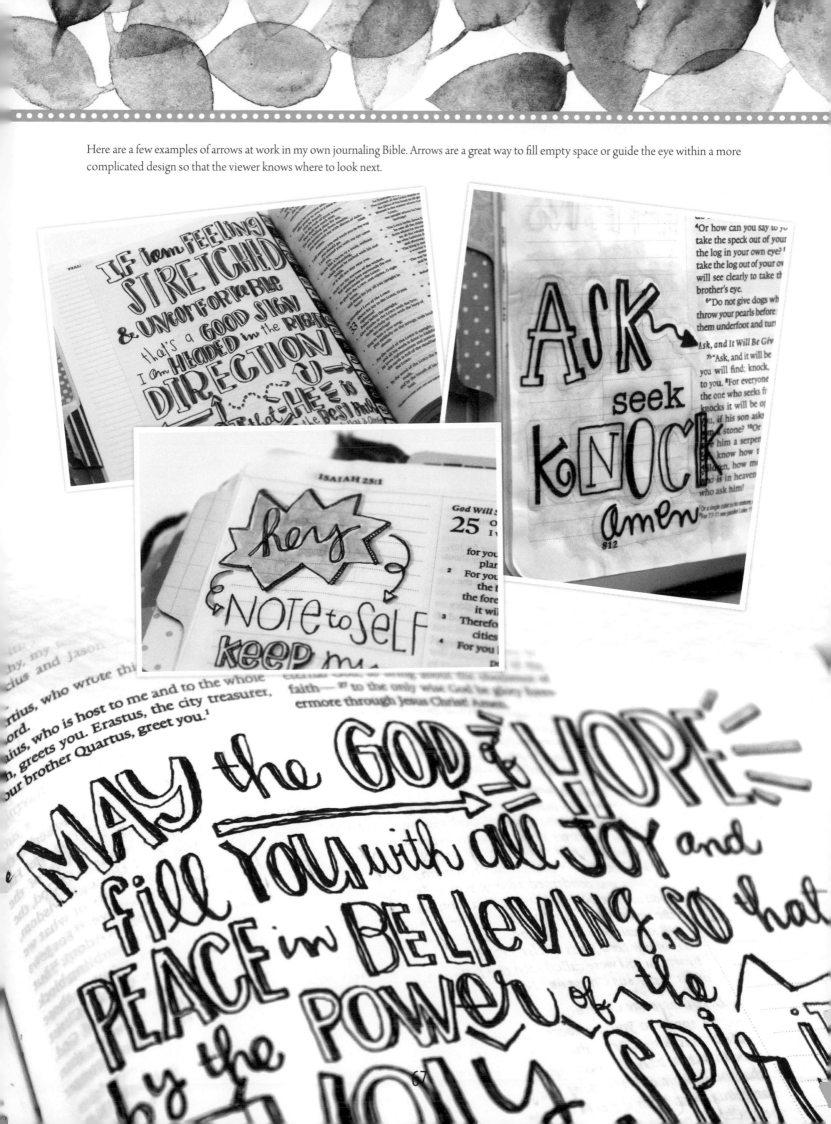

More INSPIRATION

Looking for more doodling and embellishment inspiration? Refer to the following pages for ideas for different styles of shapes, banners, wreaths, and frames that you can practice learn to master to include in your journaling artwork.

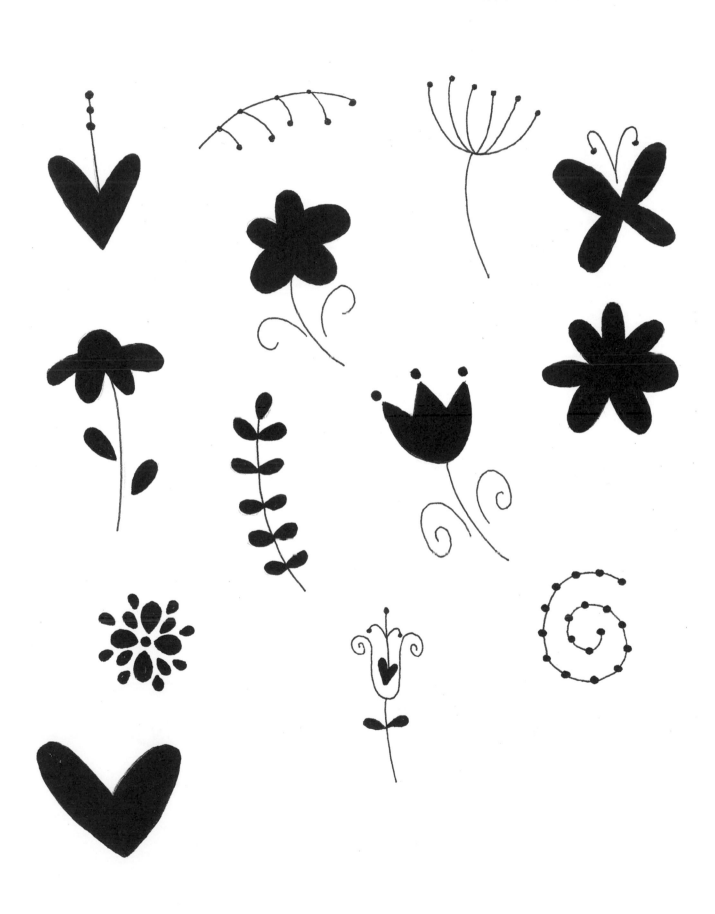

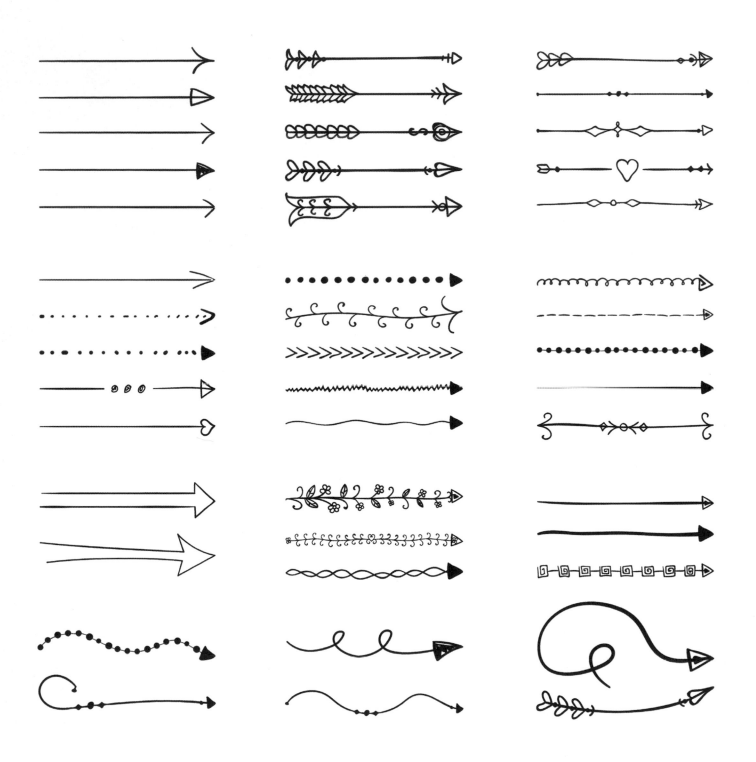

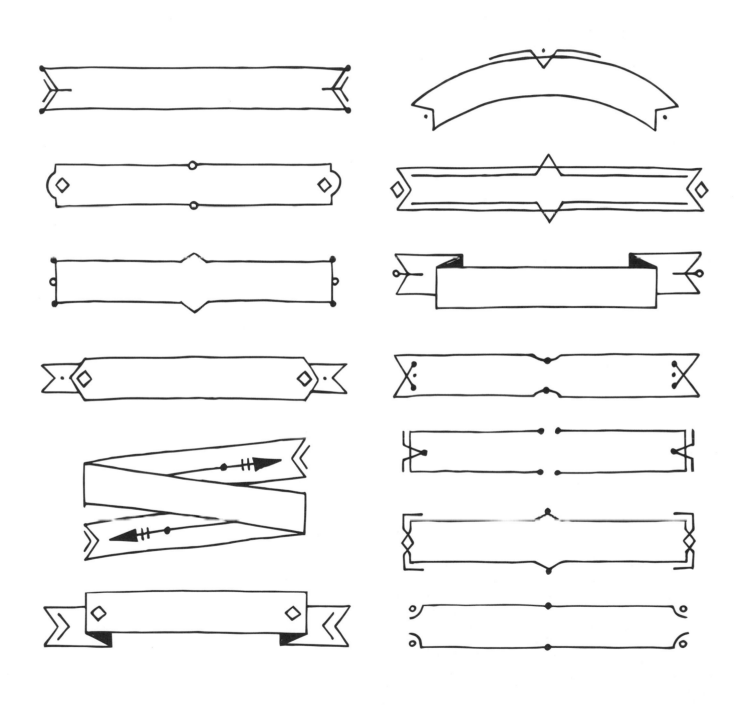

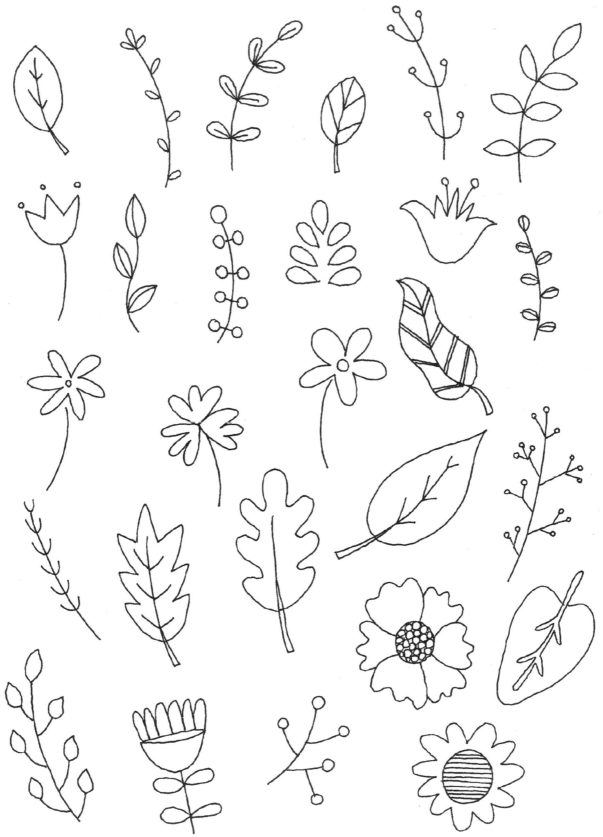

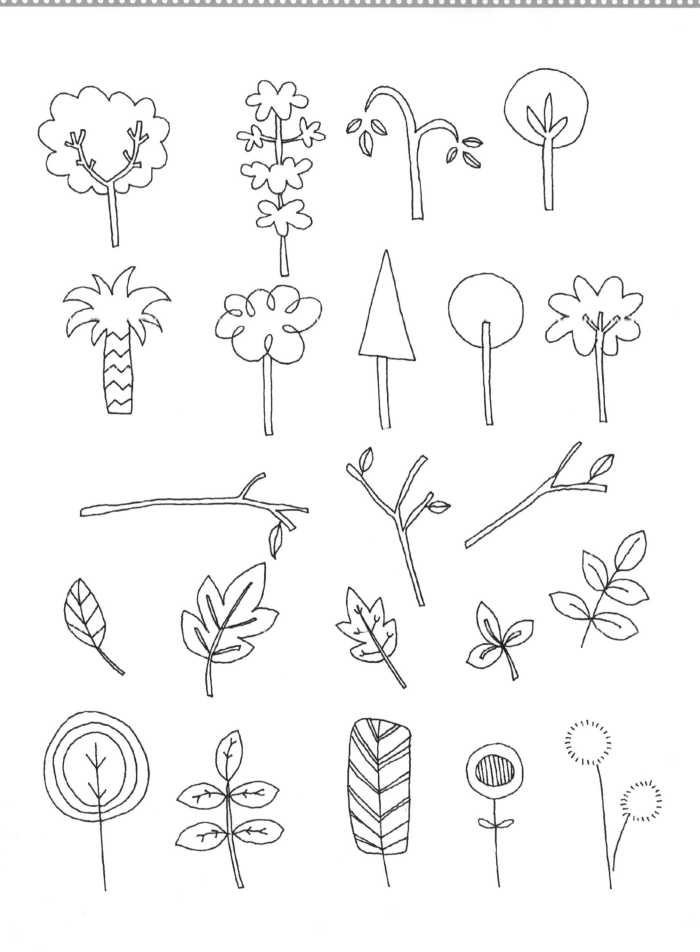

Creative Layouts & Note Taking

Creative LAYOUTS

The best way to learn how to create interesting and dynamic layouts for your lettering and journaling artwork is to practice, practice, practice. The more you experiment, the more you'll learn what does and doesn't work. Don't be afraid to try things outside of your comfort zone. You may be surprised at what you learn about yourself and your skills when you aren't afraid to push yourself.

In this tutorial, let's create a layout referencing Galatians 5:22-23. Challenge yourself to use freestyle letters, icons, and a banner with watercolors on a sheet of paper, Bible margin, planner, or journal.

Refer to this fruit of the spirit layout for inspiration and practice. You can copy my design if you like, or you can come up with your own.

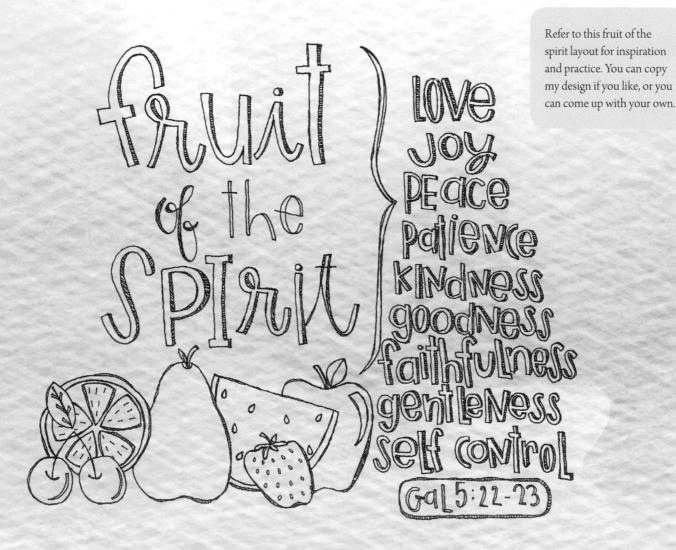

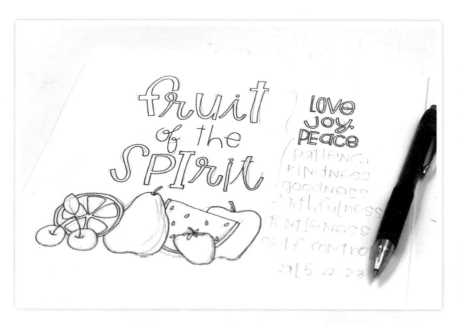

Using a pencil, write out the words using several different styles of freestyle lettering. (Refer to pages 36 and 37w if you need a refresher.) Add fruit icons and encase the verse reference (Gal. 5:22–23) in a small speech bubble or banner. Go over the entire thing with a pen, and erase the pencil lines.

Add depth, shadow, and texture to the fruit with highlights, seeds, and leaves. Double up some of the lines on the letters to create small areas of white space.

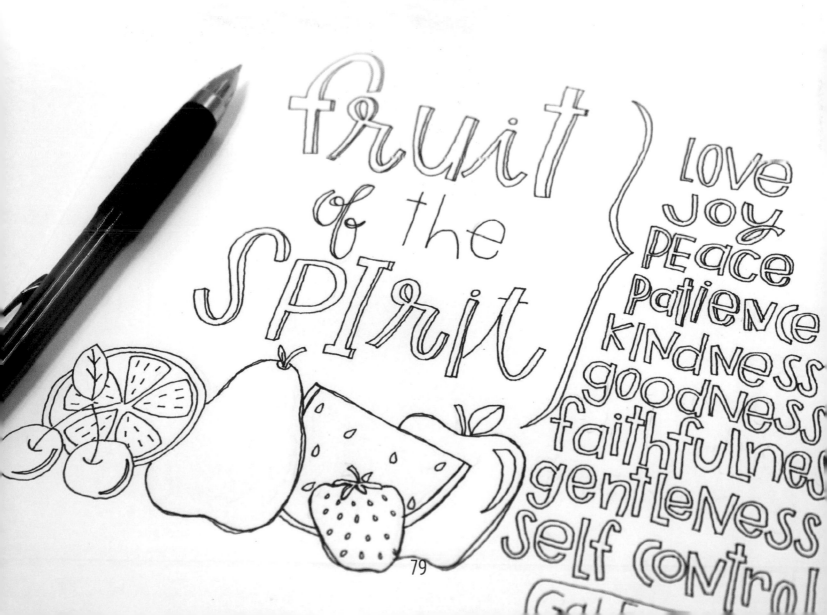

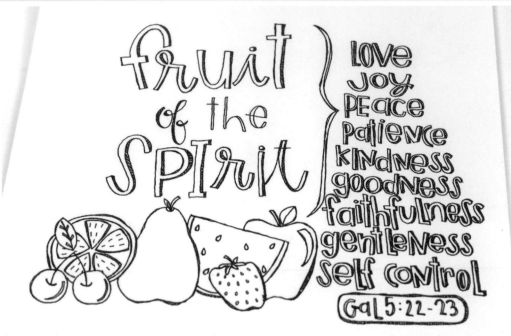

In the white spaces of the letters, add small tick marks to create texture and shading. Then take a step back to look at your art. Wherever the lines seem too faint or thin, double them up to give them a little thickness.

With watercolor paints and a wet brush, blot one or two shades of light blue around all the words and fruit. Use a slightly darker shade in some of the corners to add depth.

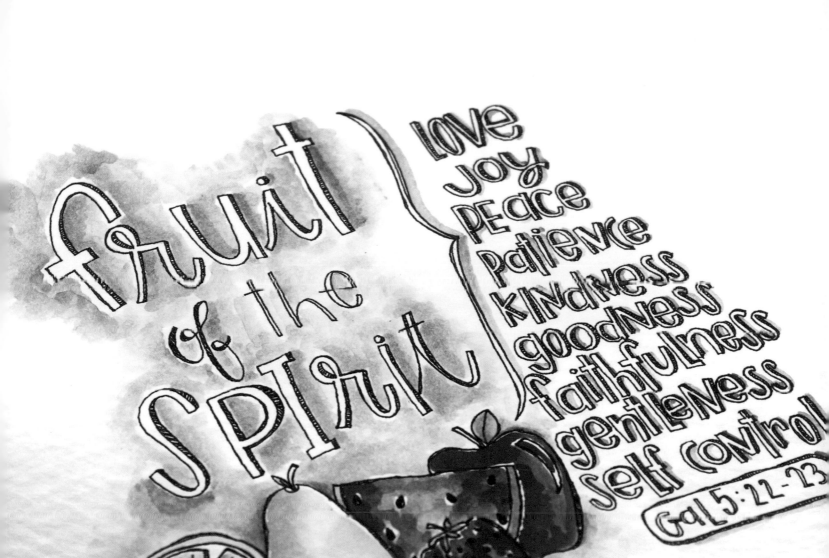

Continuing adding color to the fruit by blotting paint onto each piece, using a paper towel to blot up some of the moisture and color. Once dry, add slightly darker shades to add depth and shadow. Add light gray watercolor paint to the outside right sides of the words love, joy, peace, patience, kindness, goodness, faithfulness, gentleness, and self-control and at the bottom and right edge of the banner around the verse reference. Once the paint is dry, go back with a pen and add doodles and details to the letters and fruit.

Let's try the same exercise again with a personal statement, rather than a Bible verse. Use the phrase, "I do whatever is in front of me to be done and I leave the results up to Him." Again, you can follow along with my example, or you can try creating your own design. Below is the basic line art you can use as a reference or trace to start your own piece.

I do whatever is in front of me to Be done & I leave the results up to HIM

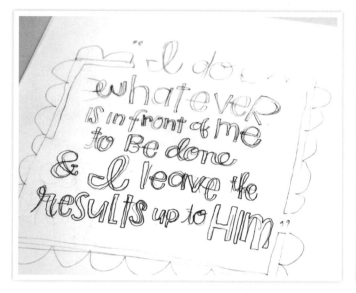

Start with a pencil outline of the letters. In this piece, I initially enclosed the phrase in a scalloped frame, but I decided not to include it in the final image.

When you're happy with the way the letters look, trace over the lines with pen, and erase the pencil marks. Double up some of the lines to add dimension.

Add color with watercolors, marker, or the medium of your choice.

I do whatever is in front of me to Be done & I leave the results up to HIM

Creative
NOTE TAKING

Usually when I take notes, one thing generally leads to another. In this section of the book, I'll share with you how I creatively take and make notes based on books and quotes I read and sermons, speakers, and podcasts I listen to.

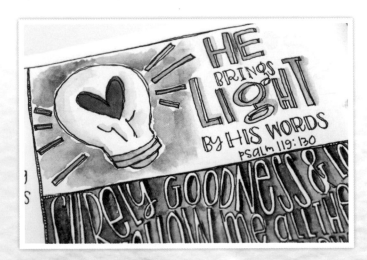

As we've discussed elsewhere, if something dawns on you after reading or hearing a statement, that may be something that you want to note in your journal or highlight in your Bible or book. I call these "Light Bulb Moments," and I often say that this is the way God "speaks" to me.

When I read something in a book and it jumps out, it typically generates a thought, and I highlight it so that I can refer to it later.

Process

Here's how the process for my creative note taking usually happens:

- I **read** something that "speaks" to me.
 - Highlight it.
 - Ask myself if it reminds me of, or applies to, a past or present situation.
 - Ask myself if it refers to a coordinating verse. If so, I write it out, circle it, and reference it.

- I **hear** something that "speaks" to me.
 - Write it down, whether it's a quote, scripture, or phrase.
 - Does it reference a verse?
 - If so, write down the verse and any other notes or thoughts that it provokes.

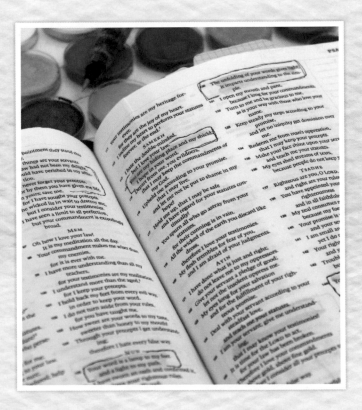

Instead of just jotting something down in sentence form, get creative with the way you take and make notes.

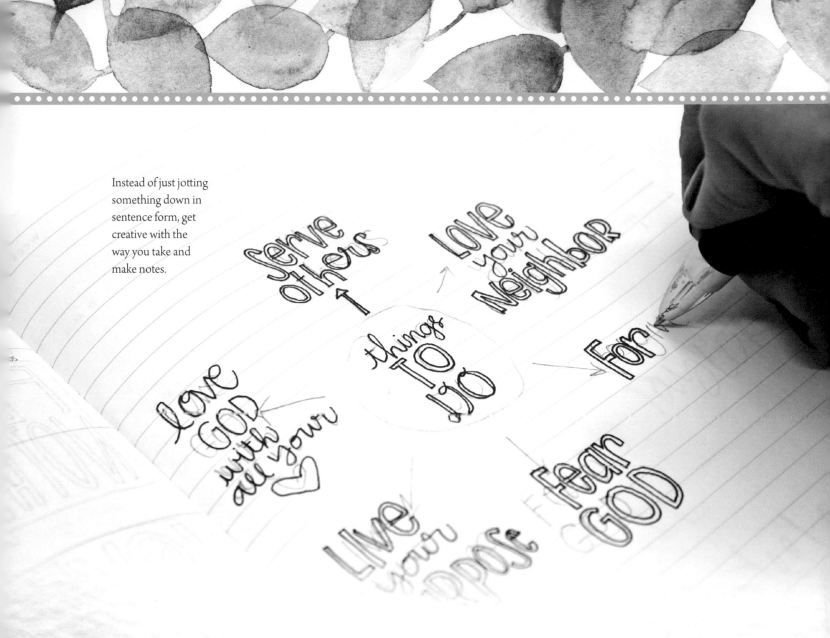

Word Bubbles

If there is a significant word, phrase, or verse that you want to jot down, consider creating a "bubble" to write it in. A speech bubble can indicate a thought and is a creative way to express something.

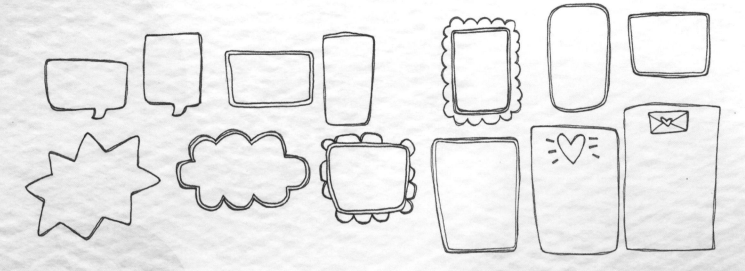

Word Emphasis

Before writing out the thought, verse, quote, or note, ask yourself what words can or should be emphasized. Consider writing out those words in bold, big fonts with different colors of ink. If you're including creative embellishments, play around with alphabet stamps and stickers to share your thoughts.

Here is a very simple formula you might follow.

Trust in the Lord with all your heart, and do not rely on your own understanding; think about Him in all your ways, and He will guide you on the right paths.

Proverbs 3:5–6 (HCSB)

STEP 1: READ & REFLECT

Read and reflect on the verse that you are inspired by. How does this Scripture apply to you and your life right now? Use the verse shown here as an example.

STEP 2: CHOOSE WORDS THAT STAND OUT

What words stand out to you in the Scripture? For example: "trust," "Lord," "all," and "heart." Write the words that stand out to you here (at left).

STEP 3: VISUALIZE

Visualize the words you chose. You might use bold, thick letters for the word "Lord." For the word "heart," try using cursive writing, and then add a heart around it.

Practice here!

Practice here!

STEP 4: DRAW IT OUT

Sketch your concept in pencil. You can do this step in the margin of your Bible or on an extra piece of paper. When you're happy with the sketch, go over the pencil lines with a pen. Let the ink dry, and then erase the pencil lines. If you use a rubber stamp to add words or images, be sure to use archival ink (waterproof /permanent).

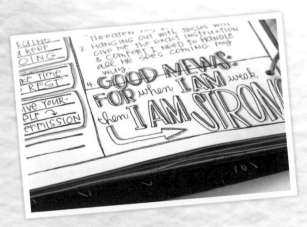

· · ·

Arrows are very popular icons, and I love to use them for function. When I start taking notes, arrows act like connect-the-dots, letting me follow along with what I've written. Check out pages 66–67 for ideas on how to draw arrows in your notes.

· · ·

STEP 5: JUST ADD COLOR

Fill your design with color using watercolors, colored pencils, crayons, or whatever other tools you like. If you are using watercolors, remember to place an extra piece of paper under the page and keep a paper towel nearby for blotting excess moisture and/or color. Stay close to the pen lines, but try your best not to go over the lines with the paint.

Stamp Carving

DIY Rubber STAMPS

You can purchase many kinds and styles of rubber stamps at any arts & crafts store or online retailer. But did you know that it's easy to make your own stamps? All you need are a few tools and a little bit of practice, and you can make virtually any kind of stamp you like for using in your journaling Bible, planner, or binder. Follow these easy tips and steps!

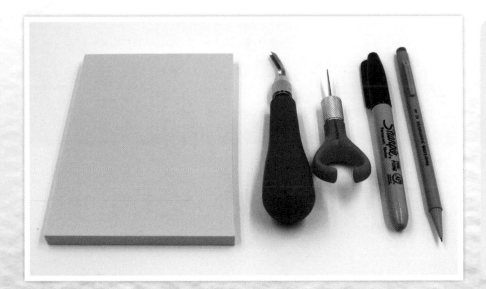

Here's a quick list of the supplies you'll need to make your own hand-carved stamps:
- Rubber carving block
- Carving handle and #5 tip
- Craft knife
- Pencil
- Paper
- Permanent marker
- Black archival ink pad

Start by cutting out a piece of carving rubber in the size you would like your stamp to be. This block is 3" x 3". Then trace the rubber piece on a piece of paper to create a template. Draw the stamp design within the traced lines and cut out the template.

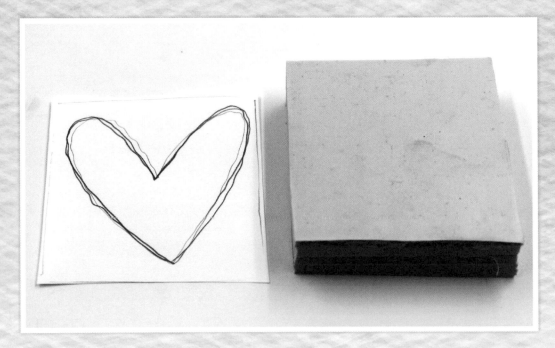

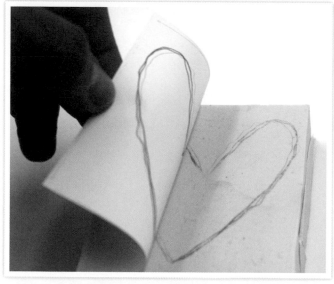

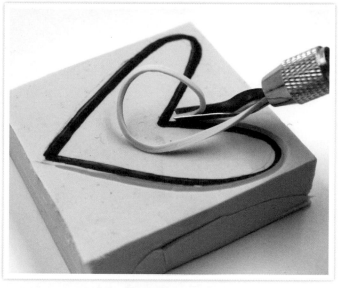

Place the template pencil-side down on the rubber. Try not to move it around; the pencil lead will transfer quickly onto the rubber. Use the pressure of your finger to press firmly over the design. Remove the paper, and the design is transferred onto the rubber.

Use a black permanent marker to define the transferred lines. For this heart design, carve around the black marker lines on both the inside and outside of the shape. Start by working your way carefully around the outside of the shape with the carving tool and #5 tip, using light pressure.

• • •

You don't need to apply much pressure with the carving tool. The rubber is soft and carves like butter. Go slow and steady, and start and stop as needed. Work with the rubber on a piece of paper, which will allow you to easily move or rotate the stamp as you work.

• • •

I like to mark the areas to be carved out with small x's as a reminder. As you approach a curve, gently and slowly swivel the rubber block around to create smooth curved lines.

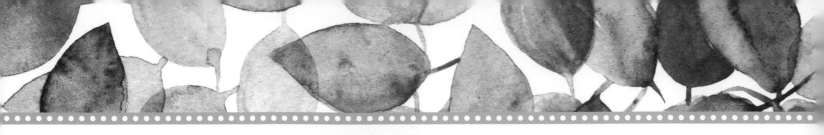

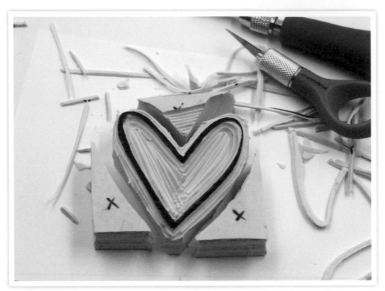

Continue until all the rubber has been carved out. Then use a craft knife to trim the excess rubber. Keep these remnants for making smaller stamps!

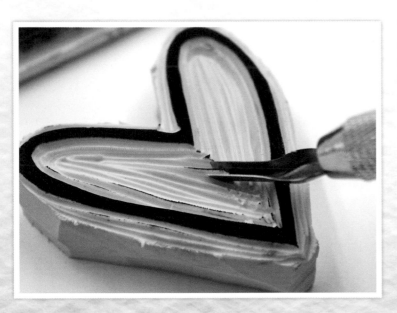

Time to test your stamp! Use an ink pad to gently ink the carved image to reveal areas of the stamp that need to be cleaned up and removed. Use the carving tool and craft knife to carve and cut away pieces of rubber that pick up ink where you don't want it.

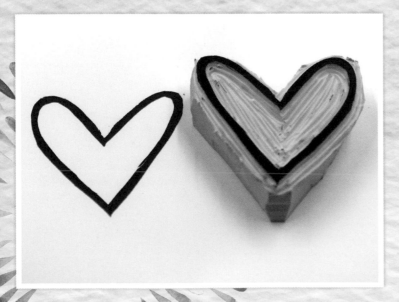

Once the stamp is cleaned up, re-ink it, and stamp onto paper to see the results. Making your own stamps is a great way to easily add hand-drawn effects and designs to your pages!

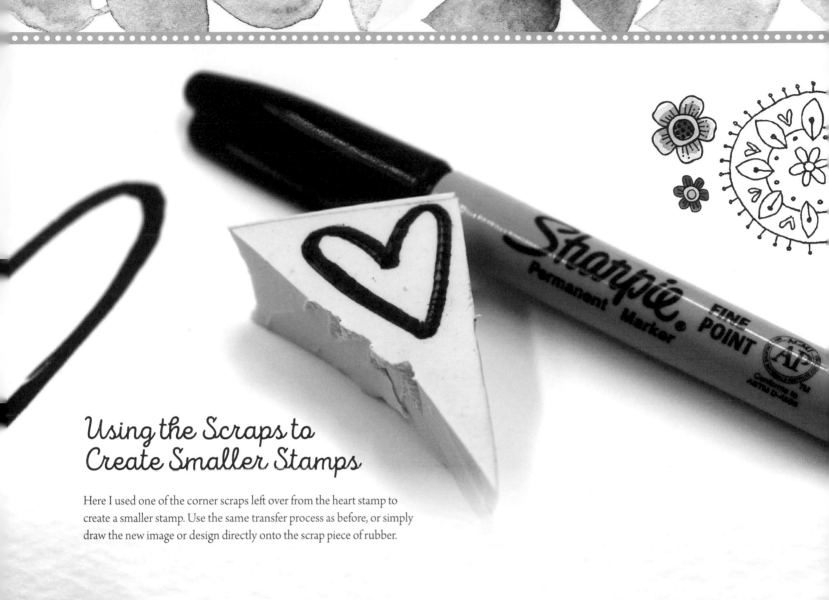

Using the Scraps to Create Smaller Stamps

Here I used one of the corner scraps left over from the heart stamp to create a smaller stamp. Use the same transfer process as before, or simply draw the new image or design directly onto the scrap piece of rubber.

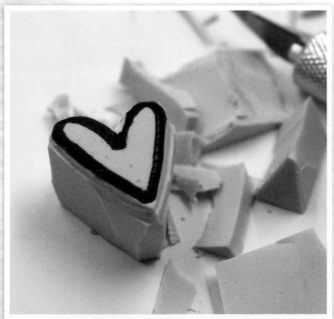

Use the carving handle and tip to remove the rubber. For this smaller heart, I decided to create a solid stamp, so I only carved around the outside.

Ink the carved image and stamp on paper to reveal any areas that need to be cleaned up.

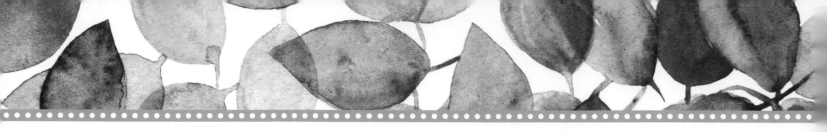

Carving WORDS

To carve out a letter or word, the image needs to be in reverse so that it reads the right way once it is stamped. All the steps are the same, when it comes to transferring and carving the stamp.

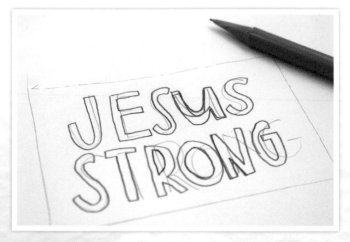

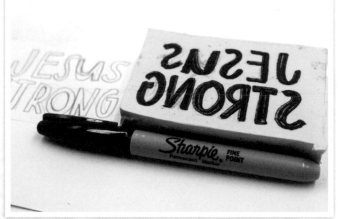

Follow the same steps on page 90 to create a template for your stamp.

Transfer the design onto the rubber. Note that the words transfer onto the stamp in reverse, making it easy for you! Use permanent marker to define the lines.

Place the rubber on a piece of paper to allow you to swivel the stamp as you work. Then use light pressure to gently begin carving out the rubber with the carving tip.

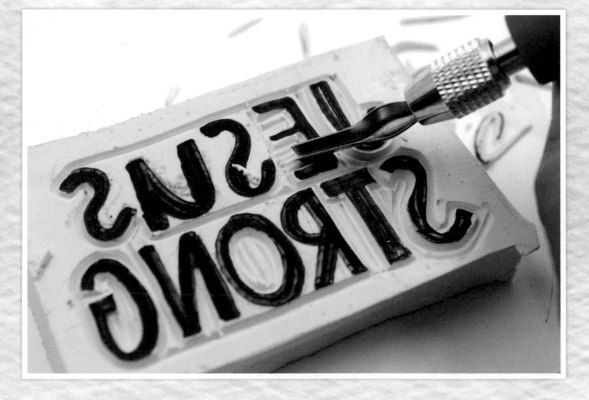

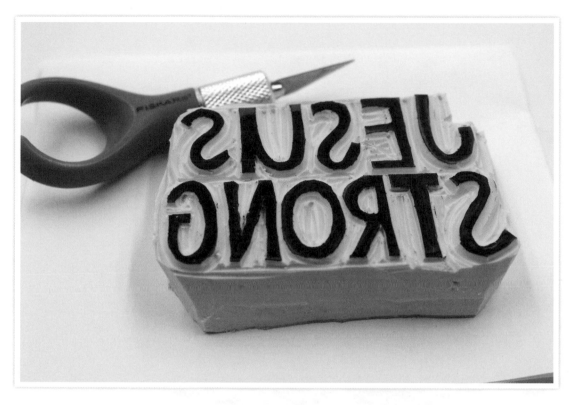

Continue carving around the words, and then use a craft knife to trim the excess rubber on all the sides of the stamp. Ink the stamp to reveal any areas the need to be cleaned up and removed.

Once you've cleaned up the stamp, re-ink the image and stamp on paper to see your beautiful new design!

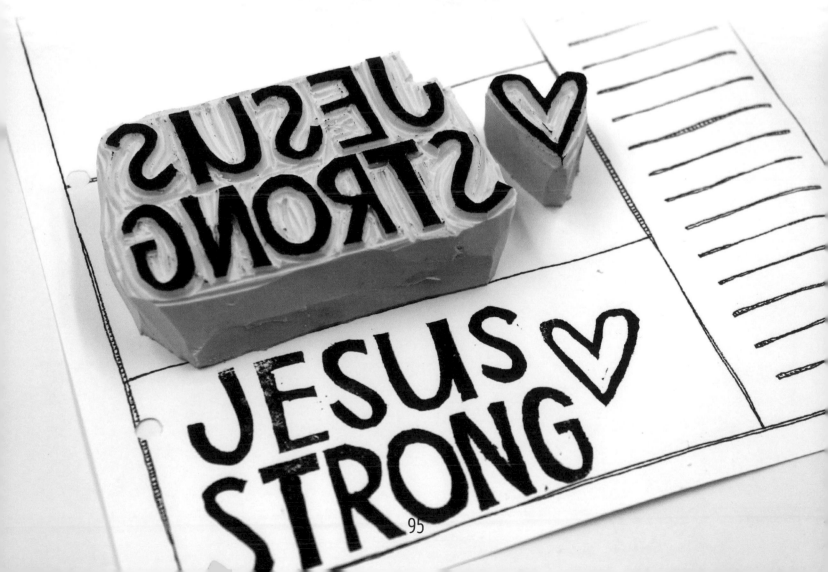

Mixed Media JOURNALING

Going beyond pencils and pens, let's explore mixed media and how to combine different mediums to create faith-based works of art. In these examples and demonstrations, I'm working in the *ESV Journaling Bible*, Interleaved Edition, from Crossway. It's a GIGANTIC Bible, because there is a blank sheet between every single page.

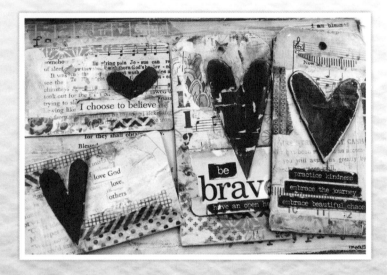

The best thing about the mixed media techniques I'll demonstrate is that you can apply them to several different surfaces.

For this demonstration, I found a page in an old hymnal that had Psalm 89 on it. I turned to that page in my Bible and decided to create a mixed media layout based on the psalm. Hymnals are an amazing resource for prayers, psalms, and readings that you can use in your art.

Mixed Media Supplies

The supplies are simple, and if you're a creative type, chances are you have some of the tools already. Challenge yourself to grab your supplies and use what you already have to create mixed media art.

- White & clear gesso
- Matte acrylic gel medium
- Foam brush
- Assorted acrylic paints
- Assorted washi tape
- Black water-based, brush pen (I like Tim Holtz® Distress® pens)
- Paper towels/baby wipes
- Heat tool*
- Assorted papers from old books, hymnals, maps, ledgers, etc.

Optional: Small, inexpensive heat tools are readily available through many arts & crafts stores and online retailers.

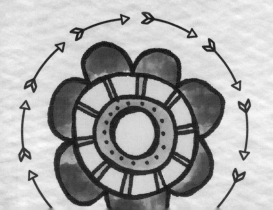

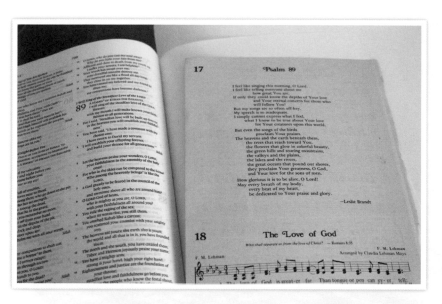

Start with a clean surface and gather all your supplies together so that you can create with ease. Because I am using gesso, a wet adhesive, and acrylic paint, I placed a piece of paper underneath the page that I'm working on to protect the other pages from splatters, spills, and bleeding.

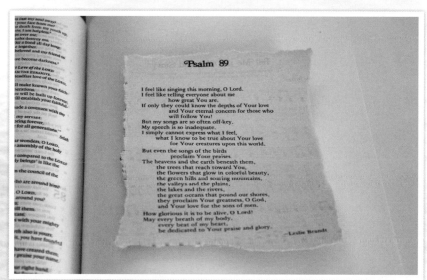

Gently tear or cut out the part of the page that you will use, and set it aside. Tearing the page will result in organic, uneven edges, which are perfect for mixed media. If you prefer cleaner lines, use scissors to cut the page.

• • •

Gesso acts as a primer that prepares the surface for paint.

• • •

Using a foam brush, add a very thin coat of clear gesso to the page. Typically, I don't cover the entire page; I use just a thin coat covering approximately three-quarters of the page. Allow to air dry, or use a heat tool to speed the drying process.

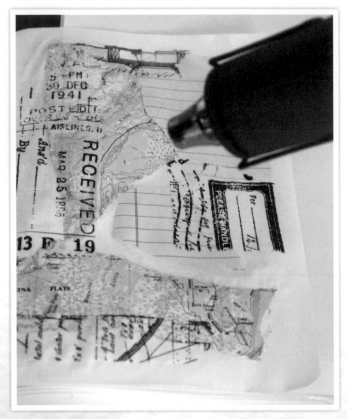

Tear up some pieces of old papers, maps, ledgers, and hymnals to collage as the background of your page. Use a foam brush to apply a very thin layer of matte acrylic gel medium on the page, and apply the collage papers. I usually don't collage all the way to the edges of the Bible page. Use a heat tool to dry the page. If you find any edges curling up, simply press them back down with a little gel medium.

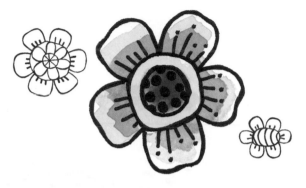

Now use your fingertip to gently smudge and smear small dabs of white gesso onto the page in several areas. Don't cover the entire page; just smudge and smear. Continue working without waiting for the gesso to dry.

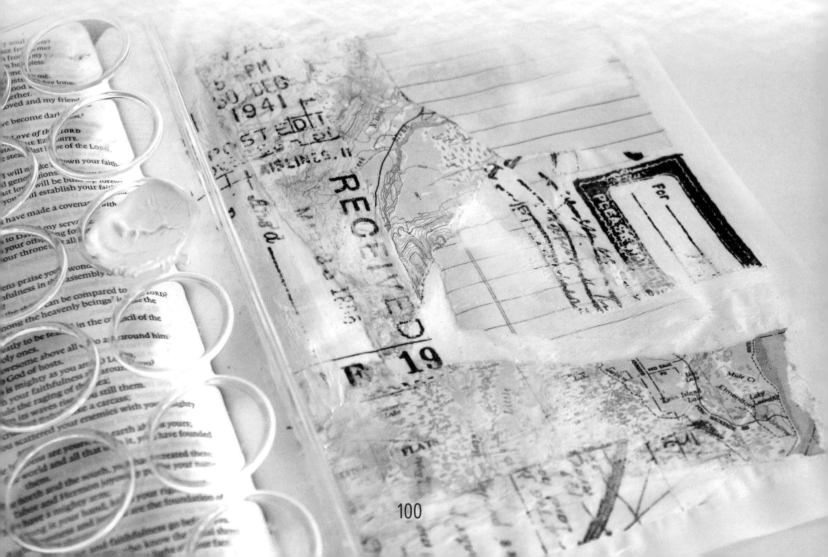

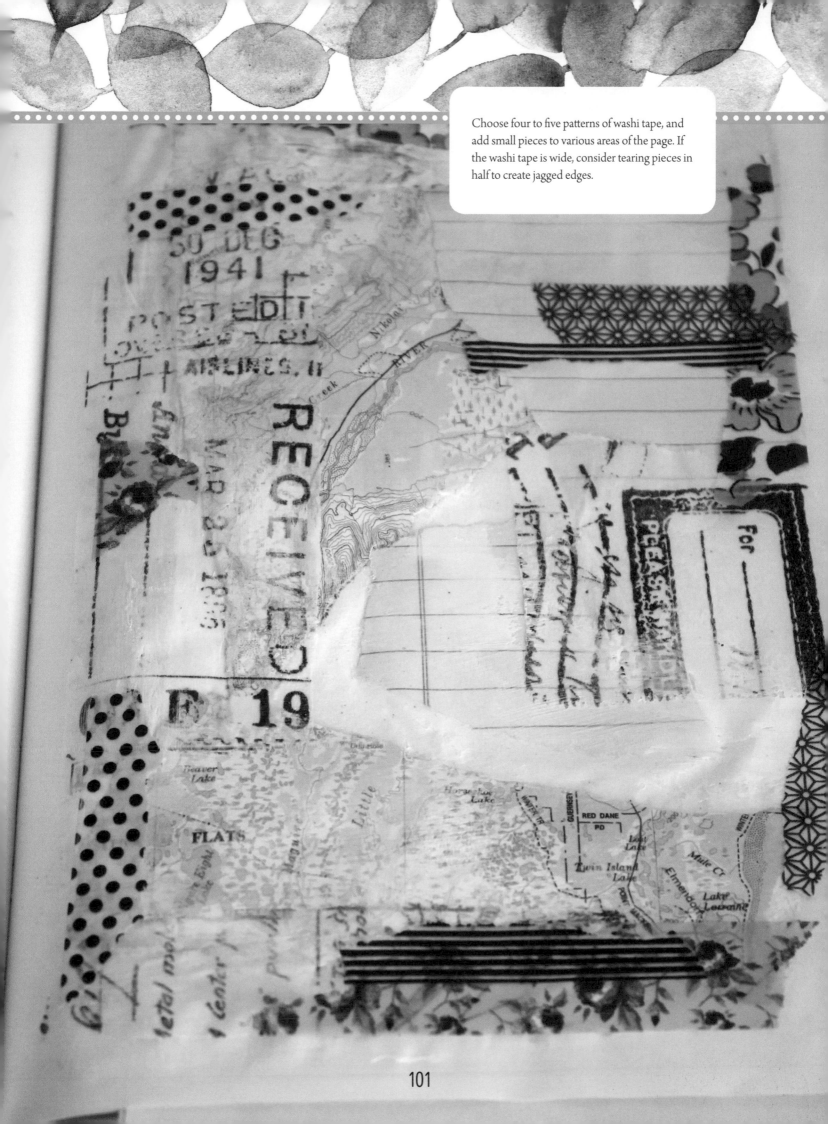

Choose four to five patterns of washi tape, and add small pieces to various areas of the page. If the washi tape is wide, consider tearing pieces in half to create jagged edges.

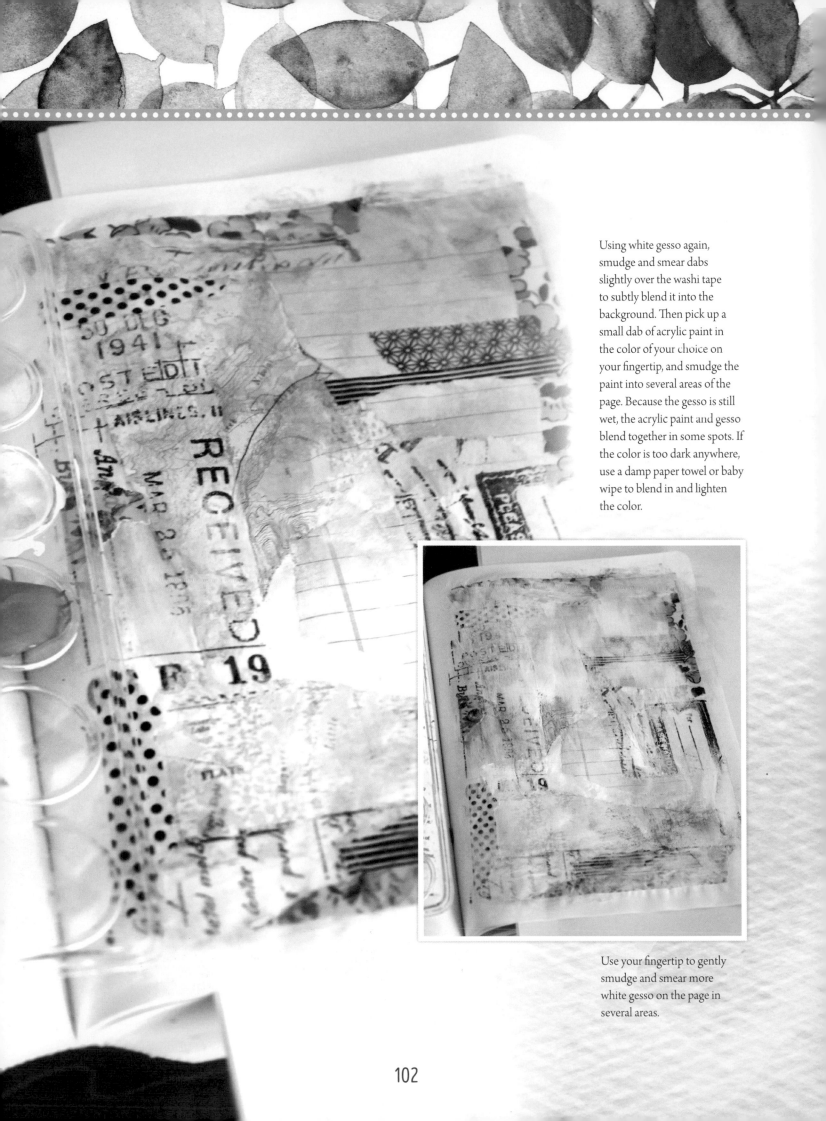

Using white gesso again, smudge and smear dabs slightly over the washi tape to subtly blend it into the background. Then pick up a small dab of acrylic paint in the color of your choice on your fingertip, and smudge the paint into several areas of the page. Because the gesso is still wet, the acrylic paint and gesso blend together in some spots. If the color is too dark anywhere, use a damp paper towel or baby wipe to blend in and lighten the color.

Use your fingertip to gently smudge and smear more white gesso on the page in several areas.

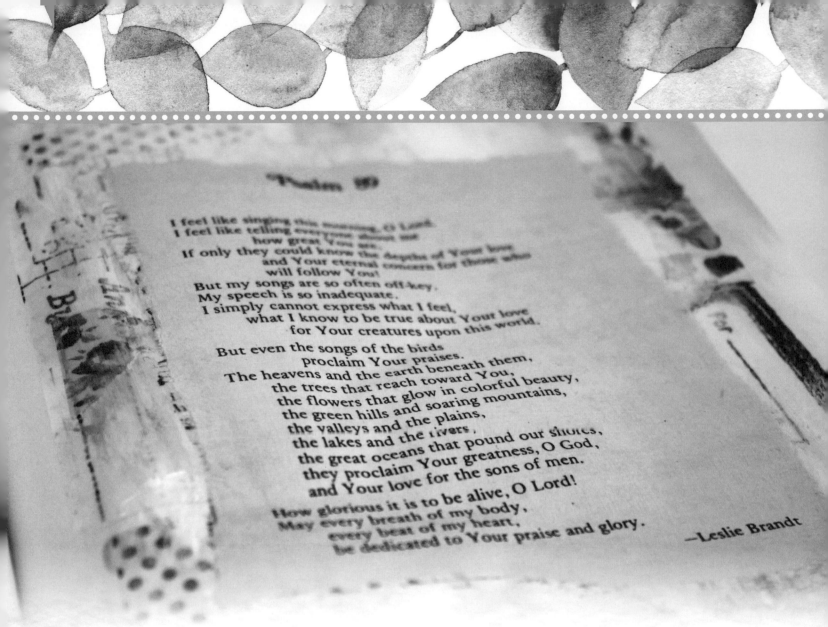

> **Psalm 89**
>
> I feel like singing this morning, O Lord.
> I feel like telling everyone about me
> how great You are.
> If only they could know the depths of Your love
> and Your eternal concern for those who
> will follow You!
> But my songs are so often off-key,
> My speech is so inadequate.
> I simply cannot express what I feel,
> what I know to be true about Your love
> for Your creatures upon this world.
>
> But even the songs of the birds
> proclaim Your praises.
> The heavens and the earth beneath them,
> the trees that reach toward You,
> the flowers that glow in colorful beauty,
> the green hills and soaring mountains,
> the valleys and the plains,
> the lakes and the rivers,
> the great oceans that pound our shores,
> they proclaim Your greatness, O God,
> and Your love for the sons of men.
>
> How glorious it is to be alive, O Lord!
> May every breath of my body,
> every beat of my heart,
> be dedicated to Your praise and glory.
>
> —Leslie Brandt

Using matte acrylic gel medium and a foam brush, apply a thin coat to the center area of the page and adhere the psalm. Use your fingers to gently smooth out any wrinkles. Dry with a heat tool, if you wish.

Paint a scrap piece of hymnal paper with red paint. Let dry, and then cut out a heart shape.

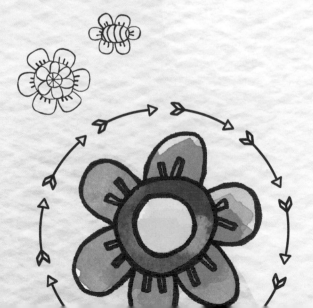

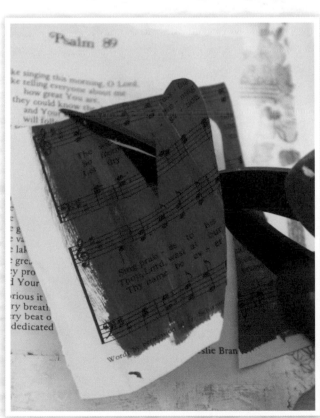

Psalm 89

I feel like singing this morning, O Lord.
I feel like telling everyone about me
 how great You are.
If only they could know the depths of Your love
 and Your eternal concern for those who
 will follow You!
But my songs are so often off-key.
My speech is so inadequate.
I simply cannot express what I feel,
 what I know to be true about Your love
 for Your creatures upon this world.

But even the songs of the birds
 proclaim Your praises.
The heavens and the earth beneath them,
 the trees that reach toward You,
 the flowers that glow in colorful beauty,
 the green hills and soaring mountains,
 the valleys and the plains,
 the lakes and the rivers,
 the great oceans that pound our shores,
 they proclaim Your greatness, O God,
 and Your love for the sons of men.

How glorious it is to be alive, O Lord!
May every breath of my body,
 every beat of my heart,
 be dedicated to Your praise and glory.

—Leslie Brandt

Experiment with placement on the page before adhering the
heart with a thin layer of matte acrylic gel medium. Smooth out
any wrinkles with your fingers, and dry with a heat tool.

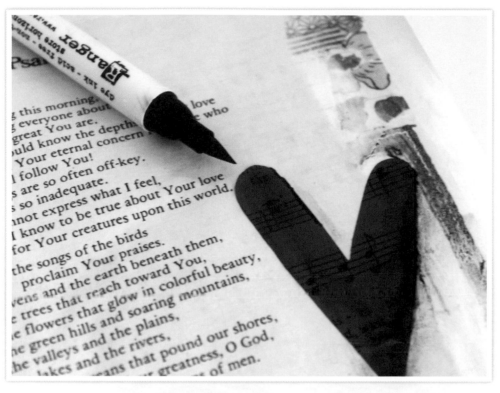

Time to add some depth and dimension to the page! Using the tip of a black water-based brush pen, very lightly add just a bit of ink around a small area of the heart. It's important to add just a little ink at a time and not just outline the heart.

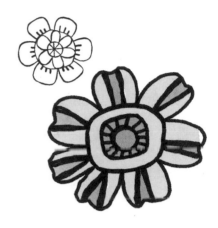

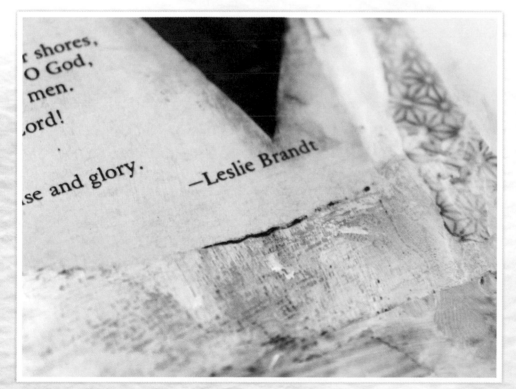

Add a very small dab of matte acrylic gel medium to your pointer finger, and gently smudge and blend the ink into the paper and the heart. It will start to blend and bleed a little, creating shadow and depth. Use a paper towel or baby wipe to clean up and lighten any areas that are too dark.

Repeat these steps, working on small bits at a time, until the heart is done. If you like, you can also use this technique lightly around the edges of the psalm, as well as some of the edges of washi tape and the collage.

All the layers work together to create mixed media art. You can use these same layering techniques on canvas, wood, chipboard, art journal pages, or even glass Christmas ornaments!

Documenting Your Faith

Documented
FAITH

"Documented Faith" (see www.documentedfaith.com) was not my idea. It was God's. I look at it as a piece of clay that He plopped down in front of me as an idea. He chose me to mold that clay into something that has been continually evolving. It is where my art and faith collide. I don't question why he chose me to lead Documented Faith, because "God does not call the equipped, He equips the called."

What Is Documented Faith?

Documented Faith is a creative way to record, illustrate, document, journal, and doodle everyday moments, Bible verses, inspirational quotes, and a growing relationship with Jesus and with others in a journaling Bible, planner, binder, art journal, notebook, or on a sticky note.

It's not about a religion—it's about a personal relationship with Jesus. It's about developing the habit of spending time reflecting, reading, worshiping, learning, and memorizing God's Word in a creative way. Documented Faith was created to remind, encourage, and inspire each other to record, illustrate, document, and journal.

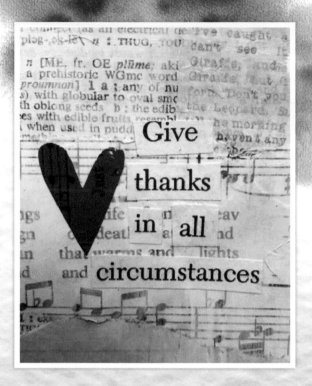

It all started out because I had a need for a place to:
- Track my physical movement
- View the month to come and look back at where I had been and what I learned along the way
- Write about my big dreams creatively, and watch how they unfold the way God has planned them
- Hold all my prayer requests, so that I can look back to see how God has worked in our lives
- Note and creatively document the wonderful, crazy, random moments of my everyday life as a daughter, a mom of boys, a wife, a friend, and a business owner
- Tape reminders of trust, love, and faith, and to read over and over and over...and then again
- Remind, record, reflect, and document my faith creatively when a 2-inch margin just isn't enough space

I had a need for it to all be in one place and to be able to take it with me, whether driving a few miles down the street or flying to the other side of the country. A place to record my life, my dreams, my prayers, my moments. A place to document my faith, sometimes monthly, oftentimes weekly, or even daily...creatively.

God does not call the equipped, He *equips* the called.

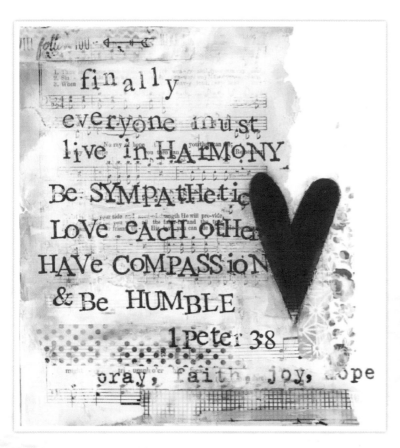

finally everyone must live in HARMONY

Be SYMPAtHetic

LoVe eAcH otHeR

HAVe COMPASSioN

& Be HUMBLE

1 Peter 3:8

pray, faith, joy, hope

Sometimes I document with just an ink pen or pencil, sometimes with photos, often with watercolor paints, LOTS of washi tape, quotes, weekly Bible verses....and in truth, sometimes with hardly anything at all.

Because I "create" for a living and work from home, all my supplies are always out and I'm always working, so I have everything I need ready for me. This also means that I wake up and go to bed with a creative mess on my table, which is *not* a great thing. I get overwhelmed, overstimulated, and grouchy, because it constantly reminds me of deadlines and time lines for what I need to get done. The remedy to all of that—the only remedy—is to put God first.

Here is the plain-and-simple *truth*: I put God first, and the rest falls into place and erases the anxiety, stress, worry, and grouchiness when I see the mess. When I give God the first of my time, He makes enough time for the rest.

For me, this means *first thing* in the morning. Sometimes I need to get up a little earlier. This may not work for everyone. But if I don't, my day is a train wreck. I want God to be the engineer and conductor of my train, because when I drive it on my own, I fall off the rails. Every single time.

I start with payer and then move to my journaling bible and my Documented Faith journal/binder. Each day looks a little different, and I don't put pressure on myself—it's all about how I feel moved to create. Sometimes I write a little in my Documented Faith journal, add a few photos, throw down some washi tape, do a little doodle, or write out a quote on a card and tape it in. I will say it a thousand times, because I want to remind both you and myself that we can do this how we want: There are no rules, just encouragement and inspiration.

. . .

Remember: This is the way I document my faith. Your methods, schedule, and execution might look different. My way may not be your way. Find your own reason, purpose, and process— and let that guide you as you document your faith.

. . .

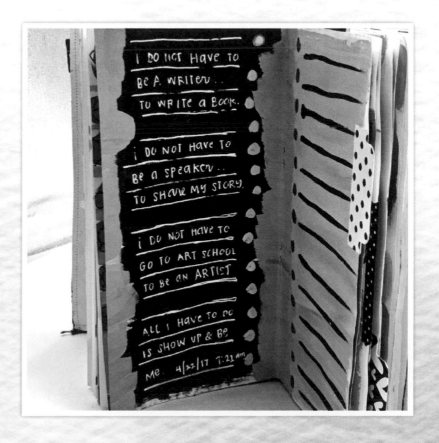

I DO NOT HAVE TO BE A WRITER TO WRITE a Book.

i DO NOT HAVE TO BE a SPEAKER TO SHARE MY STORY.

i DO NOT HAVE TO GO TO ART SCHOOL TO BE an ARTIST

ALL I HAVE TO DO IS SHOW UP & BE ME 4/22/17 7:21 am

Why Document My Faith?

What's the point of documenting your faith? To develop the habit of spending time reflecting, reading, worshiping, learning, and memorizing God's Word in a creative way. It's time to take time, make time, and spend time listening, watching, focusing, refreshing, and refueling—and together, we will grow and mature faithfully, mentally, physically, creatively, and relationally.

Together, we will take one step at a time, and those steps will turn into a walk on a new path in the unseen right direction.

Together we can do this,
through our fellowship and commitment,
our struggles and strength,
through each moment and with HOPE...

Together, we need to be quiet, pay attention,
find the center, listen, and then *create*
from what *inspires* and *influences* us.

What is Documented Faith Online?

Documented Faith is a place to find inspiration and accountability. Each month I choose a word to focus on. Each week has a Bible verse that coordinates with the monthly focus word. You can just read it, you can journal about it, you can create art based on it, you can pray about it... whatever you want to do. There are no rules. The most important thing is to create a habit of daily or weekly creative and quiet time.

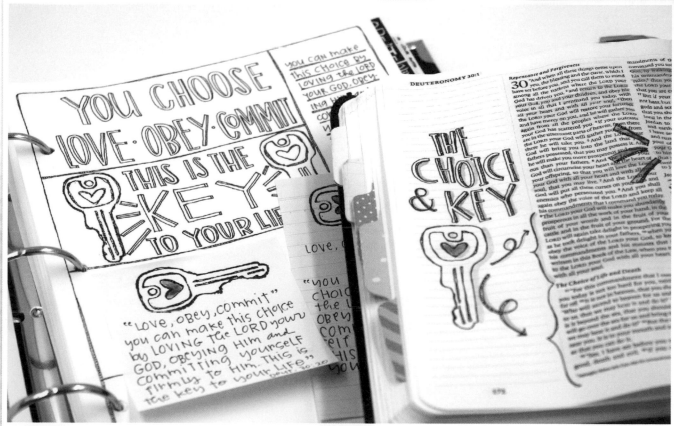

To get started, all you need to do is visit www.documentedfaith.com and register your name and email address to receive a weekly email. You can follow along monthly with a specific focus word and weekly with a verse that coordinates with that word. What and how you create is totally up to you, whether you journal, memorize, reflect, create, or simply apply the verse and word in your everyday life.

There is no start date, no end date, and no right way or wrong way to do it—just gentle, persistent encouragement in the way of an email with a verse that lands in your inbox once a week. That's it. What you do next is up to you. Some take the verse and create cards to share with others. Some rewrite it in another translation in the margin of their Bible. Some just read the verse.

Ready for more inspiration and ideas to jump-start your faith journaling? Turn the page to find prompts, suggested verses to explore, and templates to help you get started!

Exploring Bible
TRANSLATIONS & VERSIONS

When it comes to Bibles, there are dozens of different translations and versions available—you may even already have a favorite. The Bible was originally written in Hebrew and Aramaic (Old Testament) and Greek (New Testament). The Bible was first translated into English in 1382 by John Wycliffe.

Contemporary translations today range from word-for-word (such as the King James Version), meaning-for-meaning (such as the New International Version), and thought-for-thought (such as The Message).

It doesn't matter which translation you choose to work with. You may even want to explore multiple translations to use in your faith journaling. Shown here is a quick breakdown of some of the more popular translations available today. Many publishers provide journaling Bibles in various translations, so there is bound to be something for everyone.

• • •

It's a great practice to study the same verse in multiple translations. You may even discover something new about your favorite passages.

• • •

WORD-FOR-WORD
Word-for-word translations are more formal and often referred to as literal translations. These kinds of translations aim to retain original word order, grammar, and syntax as much as possible.

Examples of word-for-word translations: King James Version, New King James Version, English Standard Version, New American Standard Bible

MEANING-FOR-MEANING
Meaning-for-meaning translations aim for balance between literal and paraphrased translations. Depending on the subject, they may be more literal or more conversational in tone.

Examples of meaning-for-meaning translations: New International Version, Holman Christian Standard Bible, New American Bible

THOUGHT-FOR-THOUGHT
Thought-for-thought, or paraphrased, translations focus on putting the meaning of the passage into familiar, easy-to-follow language. Rather than literal, word-for-word translation, paraphrased translations aim to take the ideas from the original text and express them as accurately as possible in the contemporary language.

Examples of thought-for-thought translations: New Living Translation, The Message

Let's take a look at the same verse, John 3:16, in several different translations. Note the subtle variations across the translations. Some are very similar to one another; some are quite different. Overall, however, the message of the verse is the same across each translation.

KING JAMES VERSION
For God so loved the world, that he gave his only begotten Son, that whosoever believeth in him should not perish, but have everlasting life.

NEW AMERICAN STANDARD BIBLE
For God so loved the world, that He gave His only begotten Son, that whoever believes in Him shall not perish, but have eternal life.

NEW LIVING TRANSLATION
For this is how God loved the world: He gave his one and only Son, so that everyone who believes in him will not perish but have eternal life.

CONTEMPORARY ENGLISH VERSION
God loved the people of this world so much that he gave his only Son, so that everyone who has faith in him will have eternal life and never really die.

NEW INTERNATIONAL READERS' VERSION
God so loved the world that he gave his one and only Son. Anyone who believes in him will not die but will have eternal life.

THE MESSAGE
This is how much God loved the world: He gave his Son, his one and only Son. And this is why: so that no one need be destroyed; by believing in him, anyone can have a whole and lasting life. God didn't go to all the trouble of sending his Son merely to point an accusing finger, telling the world how bad it was. He came to help, to put the world right again. Anyone who trusts in him is acquitted; anyone who refuses to trust him has long since been under the death sentence without knowing it. And why? Because of that person's failure to believe in the one-of-a-kind Son of God when introduced to him.

THE VOICE
For God expressed His love for the world in this way: He gave His only Son so that whoever believes in Him will not face everlasting destruction, but will have everlasting life.

Verses
TO LIVE BY

If you're not sure where to start, take a look at these suggested Bible verses for something that "speaks" to you. Each verse indicates which translation of the Bible it's from. Remember that you can always look up a verse in another translation, and there's nothing wrong with mixing translations in your faith journaling art.

God resists the proud, but gives grace to the humble.

James 4:6 (NKJV)

I am making everything new!

Revelation 21:5 (NLT)

Let us run with endurance the race God has set before us.

Hebrews 12:1 (NLT)

For God has not given us a spirit of timidity,
but of power and love and discipline.

2 Timothy 1:7 (NASB)

The Lord is my light and my salvation;
whom shall I fear? The Lord is the strength
of my life; of whom shall I be afraid?

Psalm 27:1 (KJV)

love
EACH other
AS I have
LOVED you
- JOHN 15:12 -

In the beginning was the Word, and the Word
was with God, and the Word was God.

John 1:1 (NIV)

Therefore, as God's chosen people,
holy and dearly loved, clothe
yourselves with compassion, kindness,
humility, gentleness, and patience.

Colossians 3:12 (NIV)

It is no longer I who live, but Christ who lives in me.

Galatians 2:20 (NLT)

The Lord your God is with you wherever you go.

Joshua 1:9 (NLT)

For you formed my inward parts; you knitted me together in my
mother's womb. I praise you, for I am fearfully and wonderfully
made. Wonderful are your works; my soul knows it very well.

Psalm 139:13–14 (ESV)

"For I know the plans I have for you," declares
the Lord, "plans to prosper you and not to harm
you, plans to give you hope and a future."

Jeremiah 29:11 (NIV)

ABOVE ALL,

LOVE

EACH OTHER

Deeply,

BECAUSE

love

COVERS OVER A

multitude

OF SINS

- 1 PETER 4:8 -

Because of the Lord's great
love we are not consumed, for
his compassions never fail.

Lamentations 3:22 (NIV)

He will take delight in you with gladness. With his love, he will
calm all your fears. He will rejoice over you with joyful songs.

Zephaniah 3:17 (NLT)

Who do I have in heaven but You? And I desire nothing
on earth but You. My flesh and my heart may fail, but
God is the strength of my heart, my portion forever.

Psalm 73:25–26 (HCSB)

Therefore, if anyone is in Christ, he is a new creation; old things
have passed away; behold, all things have become new.

2 Corinthians 5:17 (NLT)

Do to others as you would have them do to you.

Luke 6:31 (NIV)

*This is the day the Lord has made.
We will rejoice and be glad in it.*

Psalm 118:24 (NKJV)

I CAN DO ALL
things
THROUGH
Christ
WHO
Strengthens
me

- PHILIPPIANS 4:13 -

I will not be shaken.

Psalm 16:8 (NIV)

Give all your worries and cares to God, for he cares about you.

1 Peter 5:7 (NLT)

Draw near to God and he will draw near to you.

James 4:8 (NKJV)

Many waters cannot quench love; rivers cannot sweep it away.

Song of Songs 8:7 (NIV)

Therefore know that the Lord your God, He is God, the faithful God who keeps covenant and mercy for a thousand generations with those who love Him and keep His commandments.

Deuteronomy 7:9 (NKJV)

Love does no wrong to others, so love fulfills the requirements of God's law.

Romans 13:10 (NLT)

Give thanks TO THE Lord FOR HE IS GOOD HIS love ENDURES forever

– psalm 107:1 –

Be anxious for nothing, but in everything by prayer and supplication, with thanksgiving, let your requests be made known to God.

Philippians 4:6 (NKJV)

Holy is the Lord God, the Almighty—who was, who is, and who is still to come.

Revelation 4:8 (NLT)

Give thanks to the Lord, for he is good.

1 Chronicles 16:34 (NIV)

But those who wait on the Lord shall renew their strength; they shall mount up with wings like eagles, they shall run and not be weary, they shall walk and not faint.

Isaiah 40:31 (NKJV)

Now faith is the assurance of things hoped for, conviction of things not seen.

Hebrews 11:1 (NASB)

He has made
EVERYTHING
beautiful
IN ITS TIME
ECCLESIASTES 3:11

Other Words
TO LIVE BY

Faith journaling doesn't have to just be about your Bible. There are many other ways to get inspired and fired up in your spiritual life, from devotional books and hymns to spiritual living books and motivational speakers. On these pages, you'll find inspiring words from great songwriters, speakers, and authors that you can explore and add to your journaling Bible, planner, faith journaling binder, or other journal. Keep a notebook handy, or a note on your smartphone, where you can record meaningful words you hear or read to use as fodder for your faith journaling.

Hymn & Song Lyrics

Amazing grace! How
sweet the sound,
That saved a wretch; like me!
I once was lost, but now am found,
Was blind, but now I see.

**Verse from "Amazing Grace,"
John Newton (1779)**

When peace like a river,
attendeth my way,
When sorrows like sea billows roll
Whatever my lot, thou
hast taught me to say
It is well, it is well, with my soul

**Verse from "When Peace Like a River,"
Horatio Gate Spafford (1873)**

Then sings my soul
My Savior, God, to Thee
How great thou art
How great thou art
Then sings my soul
My Savior, God, to Thee
How great Thou art
How great Thou art

**Chorus from "How Great Thou Art,"
Carl Gustav Boberg (1949)**

All creatures of our God and King,
lift up your voice and with us sing,
alleluia, alleluia!
O burning sun with golden beam,
and shining moon with
silver gleam,
O praise him, O praise him,
alleluia, alleluia, alleluia!

**Verse from "All Creatures of our God
and King," St. Francis of Assisi (1225)**

Praise to the Lord, the Almighty,
the King of creation!
O my soul, praise him, for he
is your health and salvation!
Come, all who hear; now to
his temple draw near,
join me in glad adoration.

Verse from "Praise to the Lord, the
Almighty," Joachim Neander (1680)

Turn your eyes upon Jesus,
Look full in His wonderful face,
And the things of earth will
grow strangely dim,
In the light of His glory and grace.

Chorus from "Turn Your Eyes Upon
Jesus," Helen Howarth Lemmel (1922)

I come to the garden alone,
While the dew is still on the roses;
And the voice I hear, falling on my ear,
The Son of God discloses.

Verse from "In the Garden," C. Austin Miles (1913)

Come, thou Fount of every blessing,
tune my heart to sing thy grace;
streams of mercy, never ceasing,
call for songs of loudest praise.
Teach me some melodious sonnet,
sung by flaming tongues above.
Praise the mount, I'm fixed upon it,
mount of God's redeeming love.

Verse from "Come Thou Fount," Robert Robinson (1758) & Martin Madan (1760)

Other Inspiring Words

Be faithful in small things because it is in them that your strength lies.

Mother Teresa

To love at all is to be vulnerable.

C.S. Lewis, *The Four Loves*

The Bible is alive, it speaks to me; it has feet, it runs after me; it has hands, it lays hold of me.

Martin Luther

We ought not to be weary of doing little things for the love of God, who regards not the greatness of the work, but the love with which it is performed.

Brother Lawrence, *The Practice of the Presence of God*

Be who God meant you to be and you will set the world on fire.

St. Catherine of Siena

To fall in love with God is the greatest romance; to seek him the greatest adventure; to find him, the greatest human achievement.

Saint Augustine

Expect great things from God!
Attempt great things for God!

William Carey

Never be afraid to trust an
unknown future to a known God.

Corrie ten Boom

Faith is taking the first step even when
you don't see the whole staircase.

Martin Luther King, Jr.

All of God's people are ordinary
people who have been made
extraordinary by the purpose
he has given them.

Oswald Chambers

God does not give us everything
we want, but He does fulfill His
promises, leading us along the best
and straightest paths to Himself.

Dietrich Bonhoeffer

The best and most beautiful things in
this world cannot be seen or even heard,
but must be felt with the heart.

Helen Keller

Templates &
Additional
Materials

DIY Stamp Templates &
COLLAGING PAPERS

Making your own stamps is an amazing way to add your unique touch to your journaling artwork. Refer to pages 90 to 95 for tips and instructions on making your own stamps. Use the designs and templates on the following pages to start your stamp collection. Simply cut out the shape, and trace/fill in the design with pencil. Lay the template facedown on a rubber carving block. Press your finger firmly over the design to transfer it to the block, and then carve away.

Use the decorative papers to create dynamic backgrounds for mixed media pieces. Cut or tear out pieces of the papers to include in your work.

The following templates and collaging papers are printed on the odd-numbered pages, so you can cut out the pieces you want to use without wasting designs on the backs of the pages.

If you like, you can use the even-numbered pages to practice doodling or lettering before you cut out the templates and papers!

· · ·

To change the size of the templates, use a photocopier or scanner to make the design as large or as small as you like.

· · ·

GOD CAN love

CAN

pray
always

let your light
SHINE

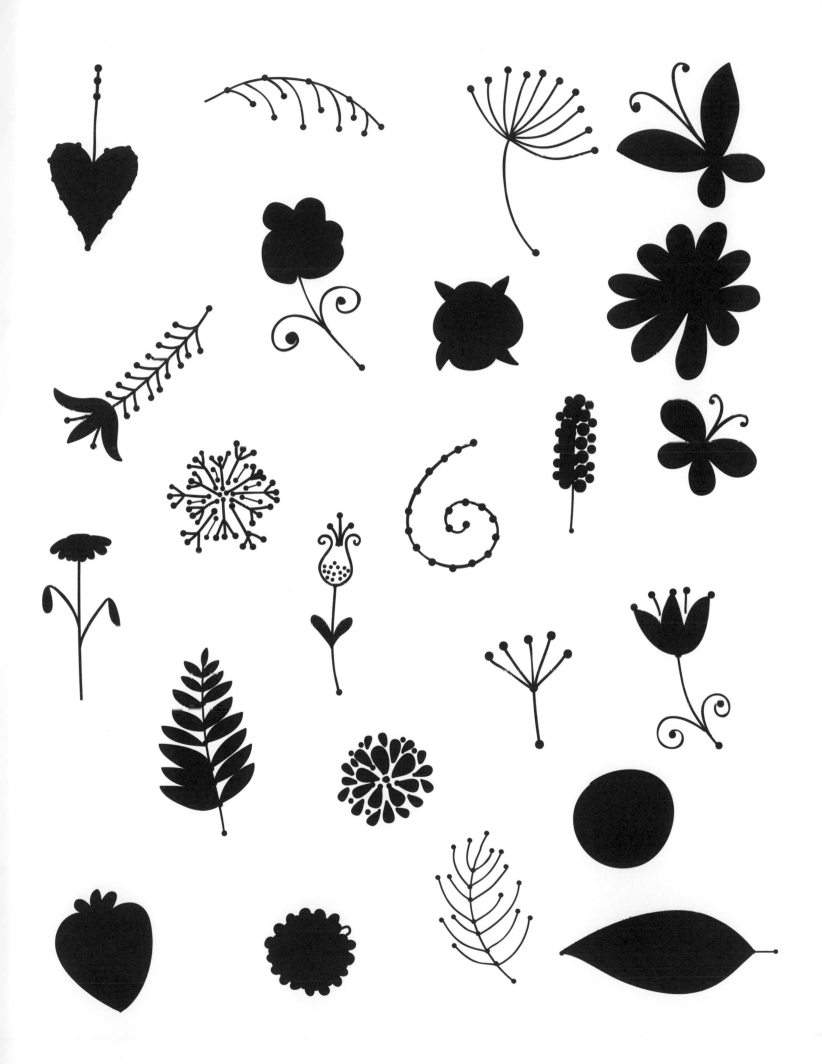

Closing THOUGHTS

The inspiration, instruction, and ideas in this book only scratch the surface of what you can do as you explore how to express yourself creatively on the pages of your journaling Bible, prayer journal, personal planner, or art journal. My hope is that you'll take all the things you've learned in this book and not only implement them in your own style, but seek ways to expand your creative expressions of faith.

Use the content in this book as a foundation upon which to build your skills. Strive to grow your artistic horizons, and never lose sight of the reason for what you're doing. It's not about perfection or creating a masterpiece. It's about the experience of spending time in reflection, meditation, prayer, and quiet time with God.

Along the way, not only will you finesse your artistic skills, but you'll find your faith affirmed and ignited daily. Happy journaling!

About the AUTHOR

STEPHANIE ACKERMAN'S purpose is to create, inspire, teach, and encourage others through creative arts. She loves to make stuff because God created her and gave her specific gifts and talents. HE is the reason for her ART, so she always includes hidden—or not so hidden—heart in her work. Sometimes she creates using paper, sometimes with batter, fabric, dough, paint, wood, or a little of each.

At any given moment, she might be praying, doodling, running, baking chocolate chip cookies, doing laundry, trying to match socks, doing more laundry, organizing piles, at the airport or coming home from the airport, stitching, taking a nap (which she does every day), or all of the above.

Stephanie is the artist and instructor behind *Documented Faith*, an online community for creatively recording life, dreams, prayers, and everyday moments. Visit www.stephanieackermandesigns.com or www.documentedfaith.com to learn more.

Color in the bookmarks with colored pencils, markers, or crayons.
Then cut them out and use them in your Bible, devotional book, or other inspirational reading.

I AM THE WAY, THE TRUTH & THE LIFE. NO ONE CAN COME TO THE FATHER EXCEPT THROUGH ME.

Surrender HOPE FAITH Humility COURAGE TRUST PATIENCE Forgiveness LOVE

BLOOM

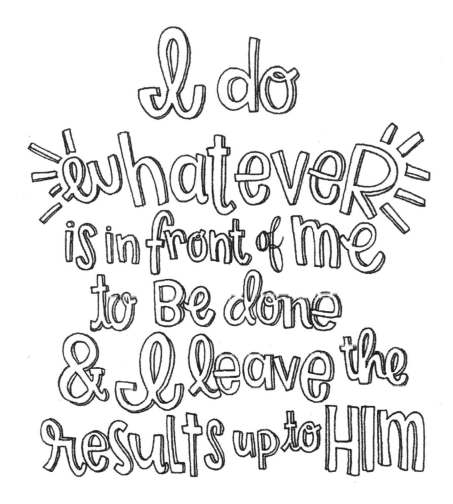

I do whatever is in front of me to Be done & I leave the results up to HIM

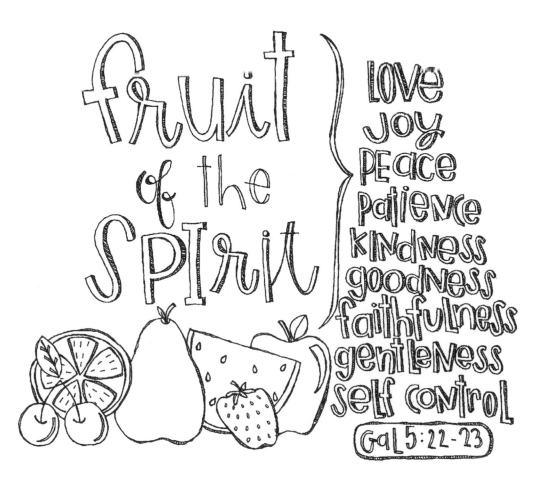

fruit of the SPIRIT

love
joy
PEACE
Patience
kindness
goodness
faithfulness
gentleness
self control
Gal 5:22-23

Color in the artwork and add a phrase or verse in the frame. Cut it out to insert into your journaling Bible, planner, or other journal—or place it somewhere you can see it daily as a positive reminder.

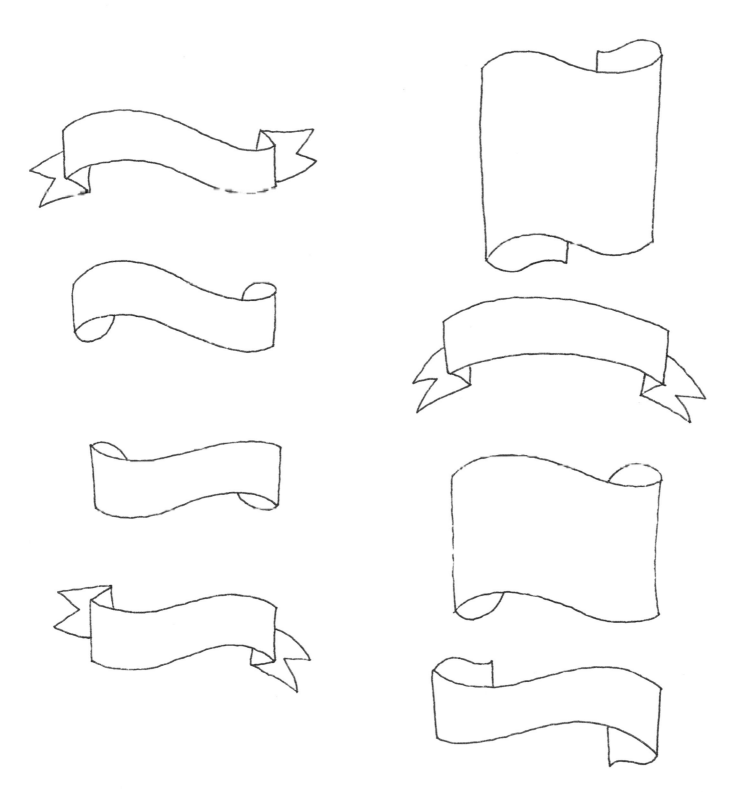

Color in the artwork and add a phrase or verse in the frame. Cut it out to insert into your journaling Bible, planner, or other journal—or place it somewhere you can see it daily as a positive reminder.

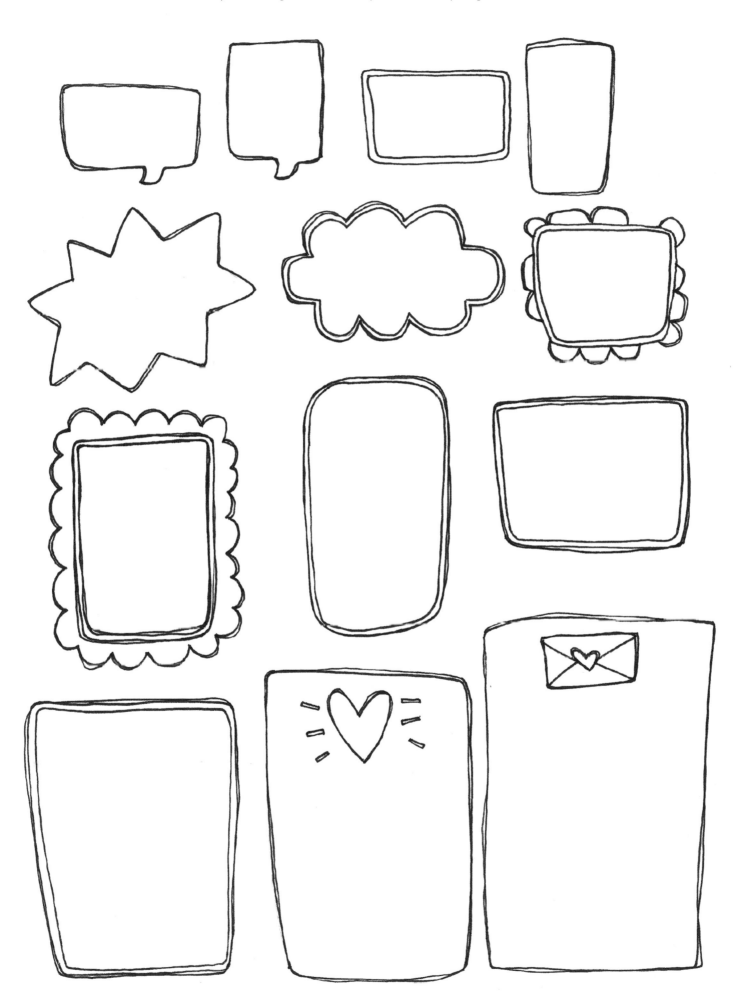